D0933458

IMAGES
*of America*

# COTUIT
# AND SANTUIT

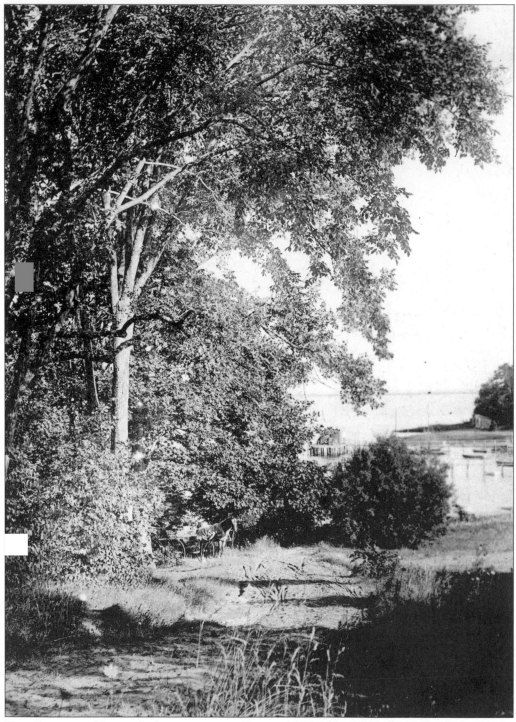

**THE ROAD TO HOOPER'S LANDING, THE EARLY 1900S.** Now Old Shore Road, this is the shortest scenic road in the town. It was laid out as a public road down to Ebenezer Crocker's dock in 1796. In this view, a horse-drawn cart struggles uphill under the elm trees in front of the Lowell house.

IMAGES
*of America*

# COTUIT
# AND SANTUIT

James W. Gould and Jessica Rapp Grassetti

First printed in 2003.

Published by Arcadia Publishing,
an imprint of Tempus Publishing Inc.
2A Cumberland Street
Charleston, SC 29401

Printed in Great Britain.

Library of Congress Catalog Card Number: 2002113745

For all general information, contact Arcadia Publishing:
Telephone 843-853-2070
Fax 843-853-0044
E-mail sales@arcadiapublishing.com

For customer service and orders:
Toll-free 1-888-313-2665

Visit us on the Internet at www.arcadiapublishing.com.

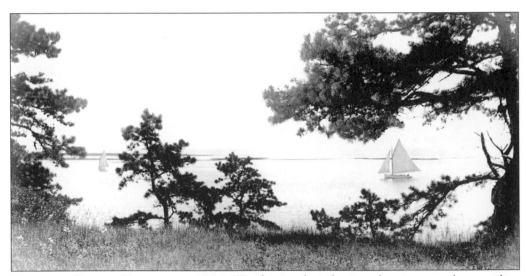

**ENTERING COTUIT HARBOR, C. 1904.** Wind-twisted pitch pines frame two catboats sailing through the west entrance. The old east passage between Dead Neck and Sampson's Island is clearly visible. (Courtesy of Sally Ropes Hinkle.)

4

# CONTENTS

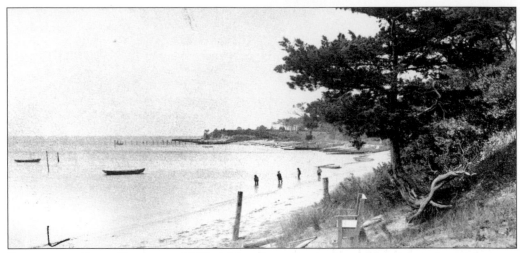

**BATHERS AT LOOP BEACH, C. 1910.** Although nor'east gales and hurricanes have taken out the carefully built sea fences and the twisted pines clinging to the bank, the fine sandy beach at Loop Beach invites bathers. (Courtesy of Charles Swartwood.)

# *Acknowledgments*

This book began more than five years ago, when our coauthor Jessica Rapp Grassetti was president of the Historical Society of Santuit and Cotuit. She realized that we had an unusual treasure of glass negatives and historical photographs. We were even more pleased when we saw the positive prints of the old slides. The result of this discovery was a permanent exhibit of 65 of the best photographs, installed at the museum in the summer of 1995.

Arcadia's proposal to publish this photographic history of Cotuit and Santuit has brought out the full efforts of our board and members. We are indebted especially to the organization of the archives by Priscilla Scudder and the scanning by our computer expert, Bill Keto. Appeals for photographs have brought to light previously unseen photographs and documents. We limited our choices for this book to those images with the best clarity or unique illustration.

We particularly thank Francis and James Barton, Roger Barzun, Louetta Bennett, John Bidwell, Robert Boden, Alma Brackett, Holly Burleson, Barbara Burrows, David Churbuck, Fred Claussen, Priscilla Cody, Ted Coleman, Jean and Merle Crocker, Zenas Crocker, Marilyn Daniels, Sarah Davis, Joan and Walter Dottridge, Ruth Ebling, Karen and Wayne Enos, Peter Field, Paul Frazier, Conrad Geyser, Ernestine Gray, Charles Hamblin, Mary and Seth Hamblin, Frank Handy, Cynthia and Bob Hayden Jr., Stephen Hayes, Sally Ropes Hinkle, Chris and Sally Jackson, Jean Layzer, Charles Lowell, Earlene MacDowell, David McGown, Cindy Nickerson, Dorothy Nickerson, Tim O'Brien, Larry Odence, Frances Parks, Francis Rennie, Francis Schmid, Edson Scudder, Racket Shreve, Robert Smith, Stan Solomon, George Souza, James Souza, Charles Swartwood, Henry Walcott, Peter Whittier, Sarah Wood, and Nancy Coleman Wyand.

Thanks also go to these very special institutions: the Cahoon Museum of American Art, the Cotuit Fire Department, the Cotuit Library, and the Holy Ghost Society of Santuit.

If your photograph does not appear here, we hope that you will let us make a copy for the archives for enlightenment of future generations.

We remember with special gratitude Nita Morse Crawford and Florence Rapp Shaw, both of whom founded the society in 1954.

# INTRODUCTION

Cotuit is a picturesque New England village with a white church steeple and many sea captains' houses lining tree-shaded streets. It lies on a peninsula, surrounded by water, and is therefore off the main road to Hyannis or Falmouth. Two and a half centuries of new buildings have produced a remarkably harmonious effect. Mansard-roofed houses, more than anywhere else on Cape Cod, have added to a dominant feeling of restrained Classicism.

A village with a long seafaring tradition, Cotuit has a fine natural harbor. It has been home to fishermen, whalers, deepwater masters, packet captains, shipbuilders, steamboat engineers, coastal skippers, and daring smugglers. (Tradition even has it that Captain Kidd landed here in 1699.) In World War II, Cotuit's Camp Candoit was the training ground for three brigades of amphibious engineers. They were called the Cape Cod Commandos and stormed beaches of the Pacific. Locally built catboats had long been popular, and in 1906, the children of the summer folk formed the Cotuit Mosquito Yacht Club. It is now the oldest junior racing club in the country.

Cotuit is the home of two favorite American dishes: cranberries and oysters. Until recently, many families in the village earned a good living from both. Cotuit oysters are now less plentiful but are still shipped all over the United States. They are renowned for their sweet flavor, which is attributed to the mixture of fresh and salty water in which they are grown. Large-scale production of cranberries was begun in Santuit by horticulturalist Abel Makepeace. Later known as the "Cranberry King," he founded the growers' cooperative Ocean Spray. Cotuit still has cranberry bogs in cultivation.

Cotuit has long been among Cape Cod's favorite resorts. The Santuit House, built in 1860, was the Cape's first hotel. In the 1890s, the Pines and the Cotuit Inn were opened. Even before the hotels, however, Cotuit was discovered by wealthy Bostonians. The first permanent summer resident was Samuel Hooper in 1849. He had made a fortune in the China trade. Among his guests, who helped spread the word about Cotuit, were writer Henry Adams and Abraham Lincoln's secretary of war, Edwin Stanton. They all seemed to enjoy the same things that attract us today—sailing, swimming in the warm seawater, and walks along the beach and through the pinewoods.

Intellectuals, artists, and other creative people have long found Cotuit a place that allowed them the peace they needed to read, write, and paint. The village was once called the "Summer Harvard." Abbott Lawrence Lowell, president of Harvard from 1909 to 1932, summered here most of his life and enjoyed the company of other eminent professors, artists, and musicians.

In more recent years, prominent psychologists, judges, foreign affairs experts, environmental pioneers, and even two Nobel laureates have vacationed here.

Cotuit has been remarkable for the diversity and tolerance of its religious expression. The Union Church, built in 1846, united three faiths and was the first community church built in America. In 1899, the Methodists built a Queen Anne–style church on School Street, which the Congregationalists joined to form the Federated Church. At one time, the village also had a Universalist congregation and a Christian Science church and reading room. Still separate are the Catholic St. Jude's and the Holy Ghost Society, one of the oldest Portuguese-American societies in America. The Syrian Orthodox church of St. Michael's is the most recent place of worship.

For the authors of this book and the many people who have contributed to it with their pictures and stories, Cotuit is a very special place. We appreciate that we are a bit off the beaten track and that many of those who live here love the old houses, the remaining open fields and woods, and the beaches that welcome walkers, clammers, sailors, and children. We hope that this book will bring happy memories to those who know Cotuit and that it will serve as an introduction to those who have yet to discover its delights.

# One
# THE UNSPOILED
# VILLAGE

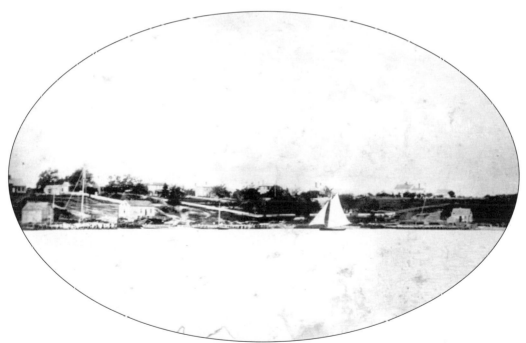

COTUIT PORT BEFORE THE CIVIL WAR, 1860. Pictured, from left to right, are the sea captains' houses on the east side of Main Street—Daniel Childs's home, Coleman's Store, Alpheus Adams's home, Braddock Coleman's Santuit House (Cape Cod's first hotel), and the homes of Hezekiah Coleman, Nathan Coleman, Joshua Ryder, and Alexander Childs. On the waterfront are the Coleman wharf and shipyard, Elijah Phinney's store, the road up to Main Street along the fence line, the office of Dr. John Brock, and Braddock Crocker's store and pier.

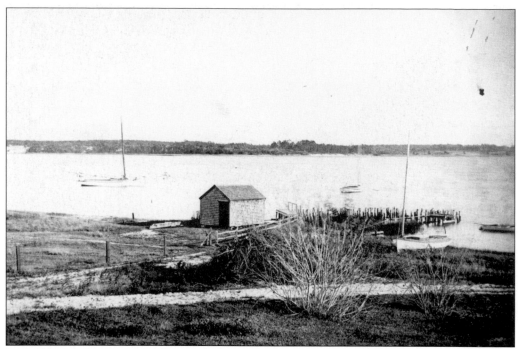

**SCREECHAM'S POINT FROM HOOPER'S LANDING.** The terrible witch Hannah Screecham, who guards Captain Kidd's hidden treasure, haunted the point in the middle distance long before Prof. Edward Channing built the first house on Grand Island in 1904. Pilings are evidence of the size of the first dock in Cotuit (dating from 1797), where Braddock Crocker set up the first village store.

**RUSHY MARSH AT OREGON, 1898.** When the Nickersons arrived from Harwich in 1810, they anchored their fishing boats in this protected harbor. They dried their codfish on flakes (racks) and built their first homes at Oregon, their original settlement. Hurricanes drove the Nickersons to Highground and sanded up the entrance to the harbor, creating this saltwater pond.

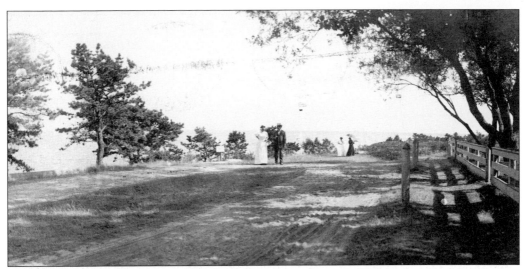

**A SUMMER STROLL TO THE LOOP, 1907.** For a grand view of Nantucket Sound, a distant glimpse of the Vineyard and Chappaquiddick, and sailboats offshore, summer visitors would stroll down Ocean View to the turnaround. One should bring a parasol to ward off the sun. (Courtesy of David Churbuck.)

**HANDY POINT AND THE NARROWS, 1908.** This view from the George Lowell lawn looks northeast toward Little River. Visible are Arthur P. DeCamp's Swiss cottage on Handy Point, the scar of the Great Whale on the Bluffs of Grand Island, and the Narrows beyond.

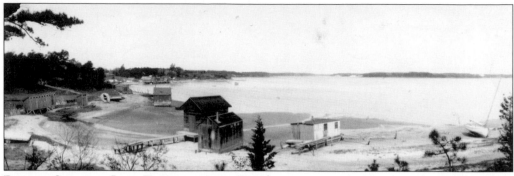

ROUND COVE AT LOW TIDE, C. 1911. Winthrop Sturges's houseboat is beached next to Nelson Nickerson's oyster shanty. Farther along the shore are, from left to right, the path leading up to the Union Church, a row of bathhouses of the Santuit House, the Sears coal and lumber dock, Elizabeth Wadsworth's summer home Tecumic, the Narrows, and only two houses on Grand Island.

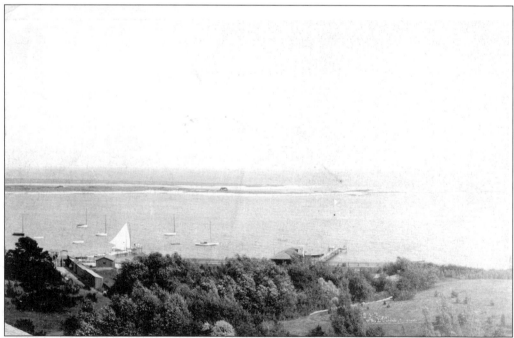

TWO ENTRANCES TO COTUIT HARBOR. Before 1910, Sampson's Island was still separated from Dead Neck by the original Cotuit Harbor entrance, which was much wider at that time than it is today. To the left are sailboats at the Pines Hotel dock, as well as a long row of bathhouses. In the center is the Rothwell pier and bathhouse. Gull Island, to the right, had pasture for a cow.

## Two

# A SEAFARING TRADITION

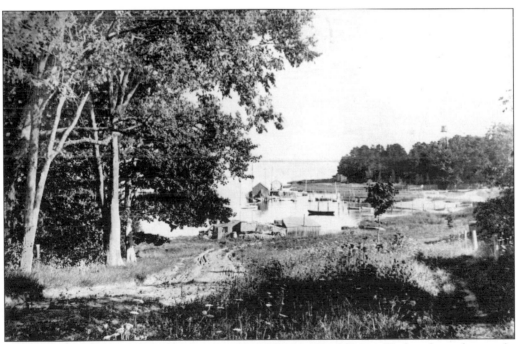

HOOPER'S LANDING, 1904. This was a visitor's first view of Cotuit Harbor from the north, with the big elm trees on the Lowell estate lining Old Shore Road to the left, Gen. John Reed's boathouse on the beach, the piers of the Santuit House and Nelson Nickerson's refreshment stand, and the water tower of Harvard president Abbott Lawrence Lowell.

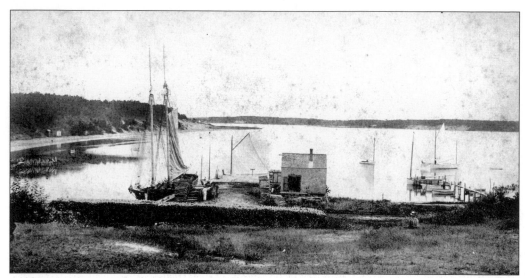

A VIEW FROM THE SANTUIT INN, THE 1880s. A two-masted schooner is taking on firewood for Nantucket while a team of horses and wagon unload on the Coleman wharf. The remnants of Cotuit Port's first dock of Braddock Crocker can be seen to the left. In the distance are Tim's Cove on Grand Island and the much eroded bare bluff before one gets to Little River. (Courtesy of David Churbuck.)

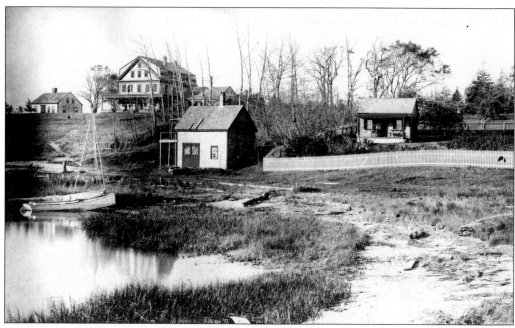

HOOPER'S LANDING, THE 1880s. The blacksmith's shop on the shore was used by Capt. Sylvanus Porter of Nova Scotia, who retired from whaling with Seth Nickerson. Directly behind the shop is the original Coleman boardinghouse, expanded to the left into the big Santuit House. To its left is the original Capt. Alpheus Adams house before it was expanded. Dr. John Brock's little house with the picket fence has been fixed up by the Hoopers.

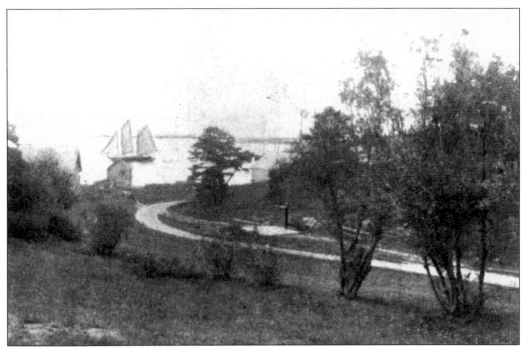

**THE OYSTER PLACE LANDING.** Before Sears opened a coal business here in 1887 and later built a dock, this town road of 1867 was merely a side landing for fishermen. The Lowell boat shed was the only building. The village hay scale indicates one of the main exports to Nantucket, on small schooners like the one lying offshore.

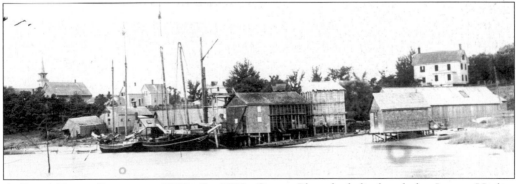

**A BUSY TOWN LANDING, 1890.** By 1899, Oyster Place had displaced the Lower Harbor (Hooper's Landing) as the center of marine activity. In the center are the coal sheds of the Sears Coal and Lumber Company. Tied up alongside are two coastal schooners, the bulk carriers of the time, bringing coal from Philadelphia and New Jersey ports. Also shown are Capt. Carlton Nickerson's boatyard and the Cotuit Oyster Company, behind the masts.

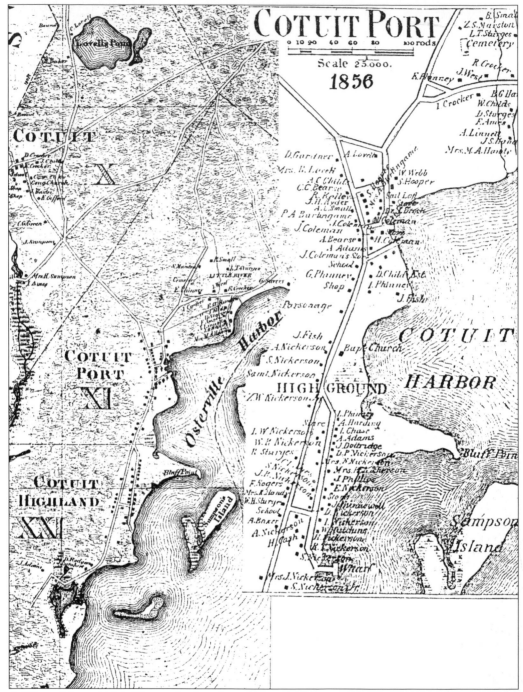

**A WALL MAP, 1856.** This is the first Cotuit map that shows individual owners' houses. It was published by the town as a huge wall hanging, a form that gets so much abuse that it is rare to find a legible copy. The Roman numerals refer to the three school districts, each of which had a one-room school.

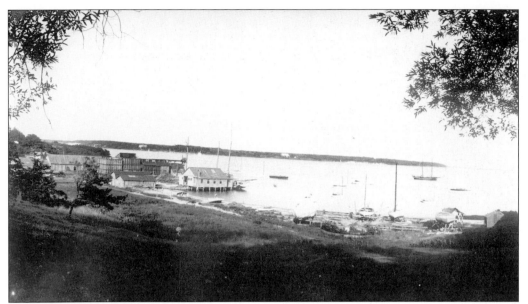

**CAPT. CARLTON NICKERSON'S BOATYARD.** This idyllic scene is Cotuit's waterfront before World War I. In the foreground is Capt. Carlton Nickerson's boatyard, where he repaired his two schooners, probably the ones offshore and at the Cotuit Oyster Company's dock. Only two houses can be seen on Grand Island. Prof. Edward Channing's is to the left, and the Storrows' Sandy House is in the center.

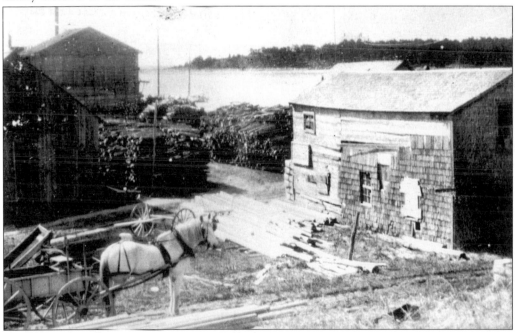

**CAPT. BENNETT DOTTRIDGE'S YARD AT OYSTER PLACE.** After he lost his son in 1895 in his third wreck at sea, Capt. Bennett Dottridge stayed ashore, running the Sears lumberyard and coal yard at what is now the town dock. A big demand for lumber kept his brother Howard Dottridge and Alonzo Phinney busy building new homes for summer folks and for people in the village.

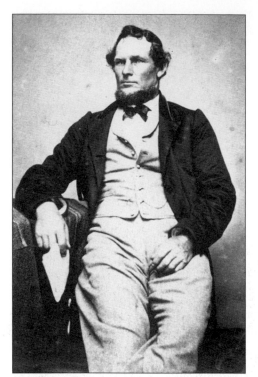

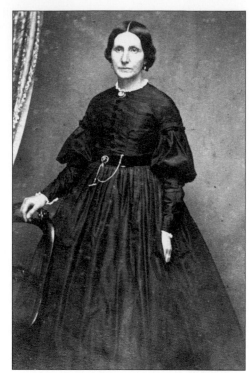

**THE BABY BROUGHT HOME IN A CASK OF RUM.** Whaling captain Seth Nickerson took his wife, Rozilla, on a three-year whaling voyage in the Pacific, where their baby Ella was born in 1848 and died at age 13 months. They put her body into a cask with her father's big ration of rum topped off by those of crew and passengers. The cask was sealed, tossed overboard on a line, and got home to Cotuit. The baby is buried in Mosswood Cemetery. (Courtesy of David Churbuck.)

*THE CUT OF HER JIB.* Seth and Rozilla Nickerson's granddaughter Clara Nickerson Boden found her grandmother's diary of the voyage in the attic and spun a romantic tale around the events, still Cotuit's favorite book after 50 years.

**CAPT. EDSON NICKERSON.** The son of Capt. Willard Nickerson and Amanda Handy, Edson Nickerson went to sea early, becoming mate of his uncle's schooners *Daylight* and *Dreadnaught*. He had unusually keen eyesight, a great asset at sea. He became master of several schooners, including the *Oliver Schofield* and *American Team*. He was successful enough to build a fine mansard-roofed house in Cotuit Highground in 1879.

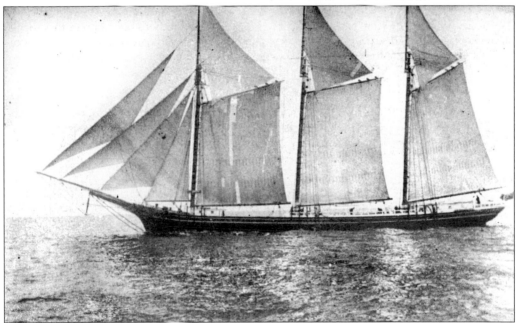

**CAPT. WILLIS NICKERSON'S SCHOONER *DAYLIGHT*.** This is a rare photograph of a Cotuit coastal schooner in full sail off Dead Neck at Deep Hole. Such craft were the bulk carriers of the 19th and early 20th centuries until World War II, hauling granite, lumber, and ice from Maine, coal and kerosene from the Delaware River and New Jersey ports, nails from Wareham, and seed oysters from Long Island Sound.

THE COTUIT WATERFRONT, C. 1911. The W.T. Jenney estate is the big house on the bluff. To the right are the Capt. Washington Robbins and Capt. Jarvis Nickerson houses, with the Carleton Nickerson boatyard below them. The cluster of buildings is Oyster Place, with the fish wharf and Sears dock.

THE OLD FISH WHARF, C. 1910. Some tired shell fishermen relax on the dock next to Carlton Nickerson's fish market, at the end of Oyster Place. A huge pile of oysters, brought in by the scow coming alongside, has been cleaned on the wooden table. The stacks of firewood may be bound for Nantucket. (Courtesy of David Churbuck.)

**CAPT. ROBERT HANDY WITH A TOP HAT.**
This vintage hat was always put on to start up a breeze during any calm. Capt. Robert Handy died in 1905. After a career in sailing coastal freight schooners, Cotuit captains often took summer people out for excursions on Cotuit Bay and Nantucket Sound in small catboats.

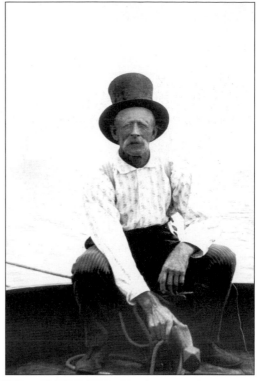

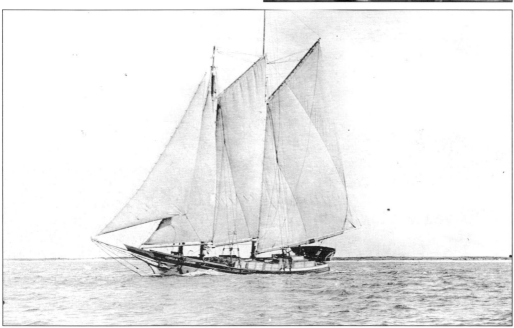

**THE SCHOONER *LOUELLA*, C. 1910.** This schooner was built by Capt. Carleton Nickerson, whom Capt. Nathaniel Parker remembered as one of the finest men he had ever known. It was named for Nickerson's wife, Louella Burlingame. Its main cargo was seed oysters, brought from Long Island Sound to beds in Cotuit Bay. Nickerson saved the life of Joshua Chase, who had been knocked overboard off Point Gammon. (Courtesy of Priscilla Scudder.)

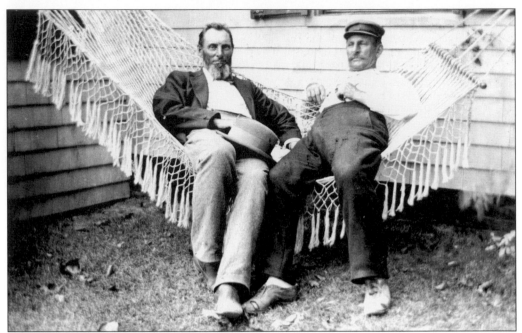

**Harrison (Left) and James Phinney.** Pictured on a hammock are two of the last Cotuit sailing captains, sons of the hard-driving Capt. Lewis Phinney and a mother who drowned herself in the salt marsh at Round Cove in 1855. James Phinney went to sea at age 9 as a cook, became captain at 20, and owned one of Cotuit's two four-masted schooners, the *Estelle*.

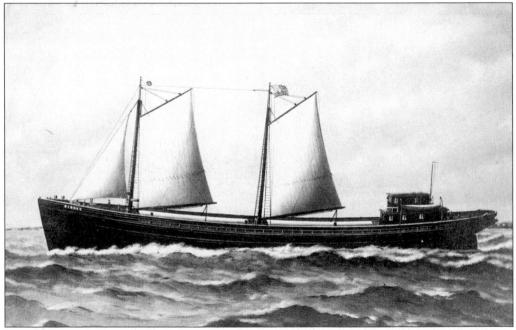

**The Barge *Sidney*, 1907.** The gaff-rigged barge was another workhorse to carry bulk cargos from coastal ports. It was slow but tough, and powerful steam winches made it easy to handle with a small crew. This one, newly built in Bath, Maine, was captained by Charles Handy, a cousin of the widowed Ellen Crocker Handy. (Courtesy of Jean Crocker.)

**Capt. Bennett Coleman, the Last Skipper.** Bennett Coleman, one of the last active Cotuit sailing masters (and one of the last in America), retired in 1942. He went to sea at age 14 as a cook. At 19, he became a mate and, at 28, a captain. Surviving the German submarines of World War I, he later lived through a gasoline explosion on another vessel. His last ship, the *Anna R. Heidritter,* was wrecked off Cape Hatteras when the U.S. Navy forced all traffic inshore with no navigation lights. Having survived this, he was killed in a taxi accident in Newark in 1942. (Courtesy of Nancy Coleman Wyand.)

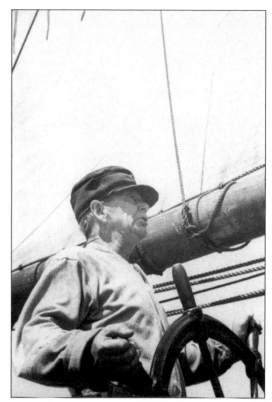

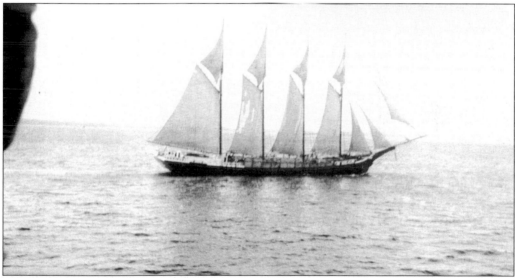

**The Last Cotuit Schooner, the Anna R. Heidritter, 1938.** This vessel was captained by Cotuit master Bennett Coleman and had a crew of six. The jib boom and bowsprit were repaired after a steamer sheered them off at Sandy Hook. It is shown here with a cargo of 564,000 feet of southern pine loaded at Charleston and bound for New York. On one voyage c. 1936—during which it was carrying 914 tons of coal from Perth Amboy, New Jersey, to Jekyll Island, Georgia—lightning split the foremast. According to the master's account, "pieces [were] flying around, but the ball of fire followed down the forestay and went overboard."

**OZIAL BAKER, HARPOONIST.** Ozial Baker died at age 84 in 1921, having served aboard Cotuit whaling ships that went into the frozen Bering Sea, the wild Antarctic, and the wide Pacific. One story tells of how his foot caught in the coil of rope that was playing out onto the harpoon lodged in the side of a rapidly escaping whale. Lifted bodily into the air on the line between whale and boat, he was reeled in (completely dry) by his fellows.

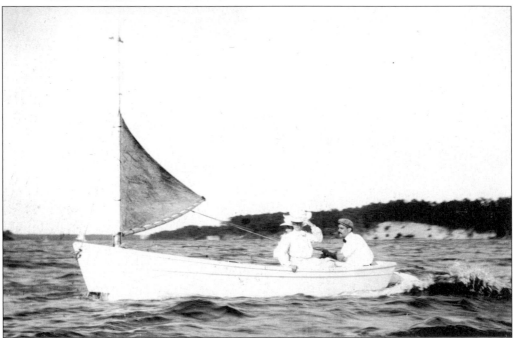

**OUT FOR A SAIL.** Hold on to your hat for a breezy sail between Handy Point and the Bluffs, with a long-vanished oyster house on Tim's Point. The shallow-draft catboats were built here in Cotuit to accommodate the shallow sandbars for oystermen and summer sailors. From this evolved the unique Cotuit skiff, now 100 years old and still racing.

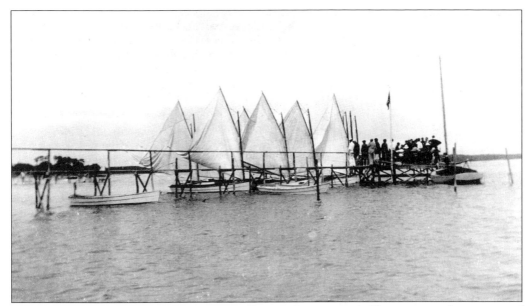

THE ORIGIN OF THE COTUIT MOSQUITO YACHT CLUB, 1906. Here is an early meeting of skippers of the first junior yacht club, on Dr. Walter Woodman's pier off Loop Beach, with Woodman's sloop *Sheila* to the right. Note the ladies on the pier, awaiting the start of the race. Dues were 50¢. No one could be over 21, and 12 of the original 15 members were young women, including the first commodore, Alice Channing. (Courtesy of Racket Shreve.)

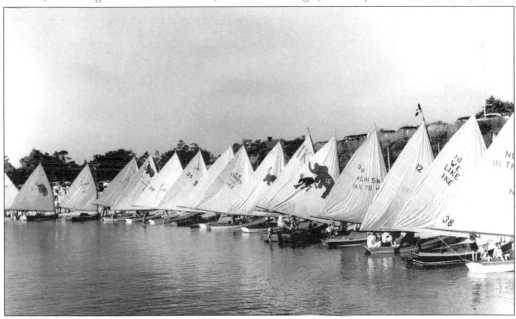

COTUIT SKIFFS, "I LIKE IKE." In August 1952, the Cotuit Mosquito Yacht Club skiffs flaunted their support for Gen. Dwight D. Eisenhower, who was elected president by the largest popular vote in history up to that time. The Democratic Jacksons gave qualified support with the sarcastic slogan "Agin Sin, Ike to Win" (No. 30) or boycotted it, as in the case of the winner of this race, Evie Jackson (No. 3). This photograph was taken at the start of the Hyannis Race in the Blue Water Series.

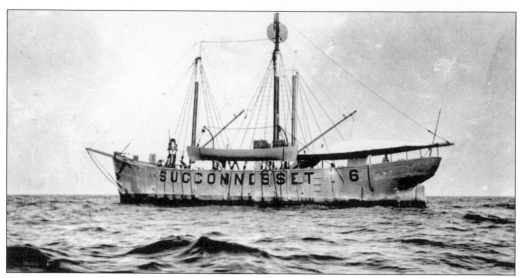

THE LIGHTSHIP SUCCONNESSET. Only three miles off the Cotuit coast, this floating lighthouse was anchored on the first big shoal that threatens sailors in Nantucket Sound. A ship was maintained here from the Civil War until 1912. Twice it broke loose when Nantucket Sound froze over, to be driven off by the ice. In its last unmooring, it disappeared off Chatham, never to be seen again.

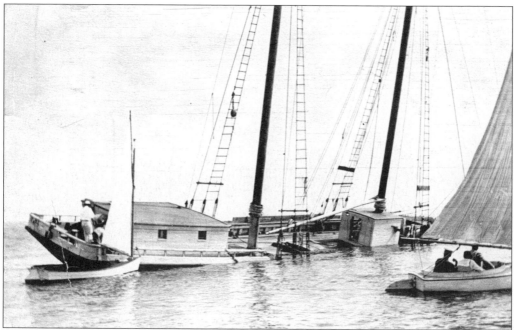

A SCHOONER WRECKED A MILE OFF COTUIT. Cape Cod is the graveyard of ships, and Cotuit has had its share of wrecks on the shifting shoals and in the blinding fogs and sudden storms. Here, a two-masted schooner is up on a shoal only a mile offshore, with a couple of Cotuit catboats alongside to help. Its fate is unknown, but one hopes it was lightened, pumped out, and floated off to safety. (Courtesy of Dorothy Nickerson.)

26

# Three

# THE BOUNTIFUL
# LAND AND SEA

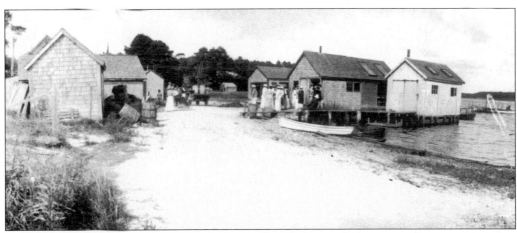

**OYSTER HOUSES IN LITTLE RIVER, C. 1912.** These ladies in their summer best are going into Ezra Hobson's oyster shack, probably for a clambake, which Hobson put on for the Order of the Eastern Star. Ezra Gifford's shanty is to the left, and Henry Robbins's is to the right. Capt. William Childs took advantage of the opening of the railroad to West Barnstable in 1854 and made a success of shipping fresh oysters from Little River to the station by wagon.

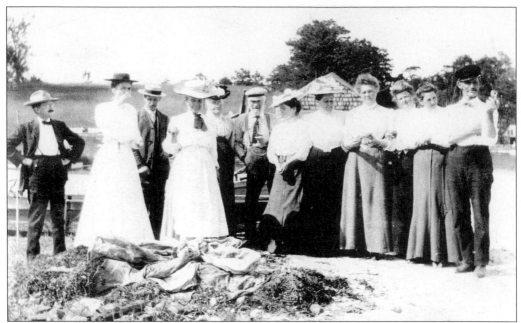

**AN OLD-FASHIONED CLAMBAKE AT LITTLE RIVER, 1912.** In this photograph taken at Ezra Gifford's oyster house, the clambake master to the right holds up his pocket watch to show the timing is perfect. The sailcloth is lifted from the steaming bake from a base of red-hot rocks topped with seaweed-wrapped lobsters, corn, and steamers. (Courtesy of Alma Brackett.)

**INSIDE EZRA GIFFORD'S OYSTER HOUSE, 1910.** Shown is a rare view of the utilitarian space of a working oyster house. The big door opens onto the water toward Oyster Grand Island. Visible are the catboats that brought the harvest to the door, to be separated, cleaned, and dropped back into the water in wire baskets until shipped out in barrels. (Courtesy of Alma Brackett.)

28

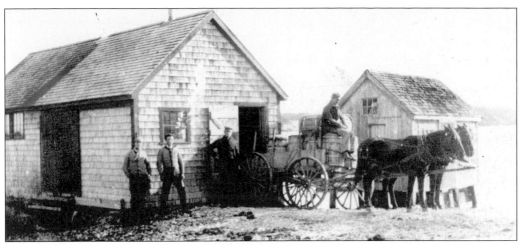

A LOAD OF OYSTERS OFF TO THE STATION, 1909. Ezra Gifford has loaded a wagon for the railroad at West Barnstable with barrels of oysters. To the right is Ezra Hobson's oyster house, one of four at Little River that farmed the beds in the Narrows and off Handy Point. All of these were wiped out by the 1938 hurricane. (Courtesy of Alma Brackett.)

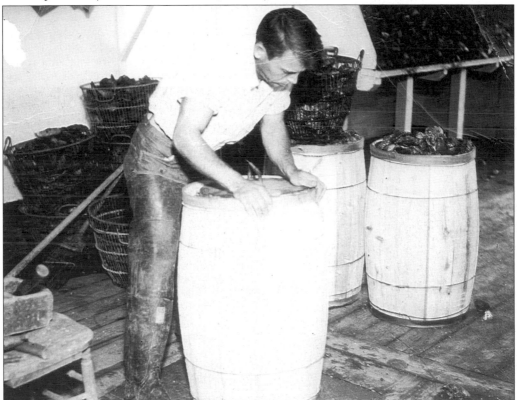

PACKING COTUIT OYSTERS. Cotuit oysters are shipped all over the nation. Here, at the Cotuit Oyster Company, Earle MacDowell places the head onto a barrel, to be closed with the mallet at his side. Twice wounded in World War II (in North Africa and Germany), he was in the first unit assigned to Camp Edwards, where he met and married a Santuit woman, Phyllis Gifford. (Courtesy of Earlene MacDowell.)

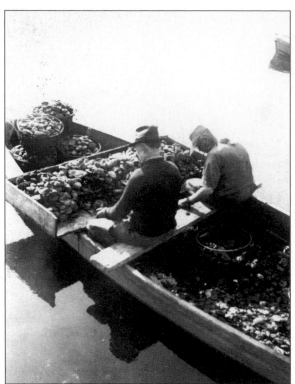

**CLEANING OYSTERS, LITTLE RIVER.** Manager of the Cotuit Oyster Company Henry Robbins and his helper set a board across their skiff to separate the clusters of oysters and remove the empty shells to which they have stuck. The dead shells and trash go into the water for the next generation of oysters to cling to.

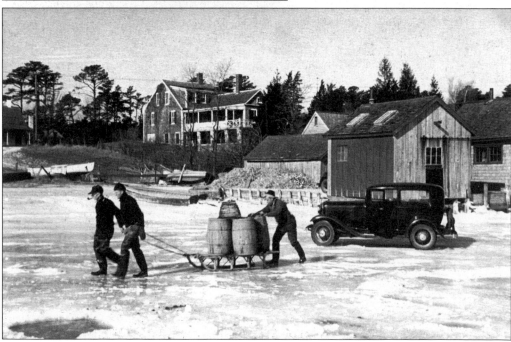

**OYSTERING IN WINTER, 1938.** Cotuit Bay usually freezes over in winter hard enough to drive a truck onto it. The ice has to be sawed to retrieve oysters from the bottom with tongs and carted ashore by sled. Here, off Little River, Henry Robbins is leading the procession. (Courtesy of Francis Barton.)

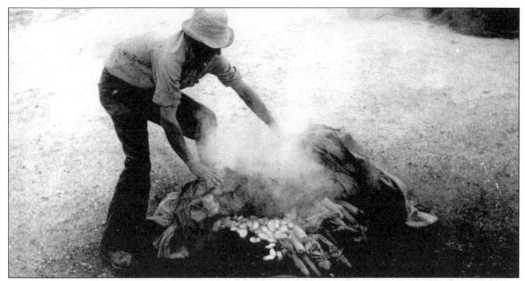

**THE GIFFORD CLAMBAKE AT LITTLE RIVER.** Smell the mouth-watering fragrance of the boiled dinner, mixed with the salty smell of seaweed in the steam as Herbert Gifford lifts the canvas from the dinner. First come the steamed clams dipped in butter, and then come the corn on the cob and the lobster. Herbert Gifford specialized in clambakes for summer celebrations after the 1954 hurricane wiped out his family oyster business. He died in 1978 at age 81.

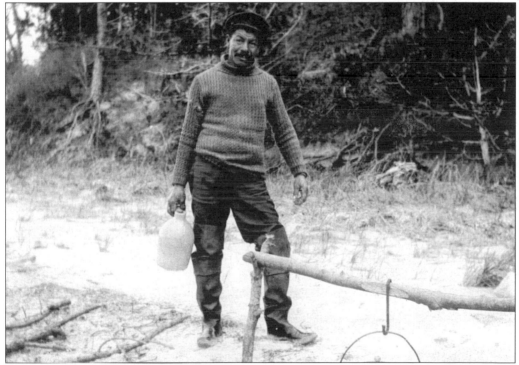

**JIM PELLS PREPARING STEAMED CLAMS.** Jim Pells served on whaling ships and jumped ship to join the Argentine navy (tougher masters than Captain Ahab). He took refuge with Argentine Indians, who helped him find his way home to Cotuit, where he made a hard living on the water, dragging for quahogs, tonging for oysters, and digging for steamers.

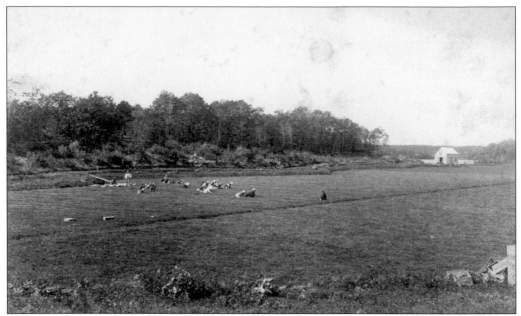

**THE CRANBERRY HARVEST IN SANTUIT, 1890.** Cranberries are still grown around Lovell's Pond and in this location. A.D. Makepeace, the "Cranberry King," opened the first big bogs in Santuit and Newtown. Here we see a boghouse, a team waiting to pick up the berries, and empty boxes stacked in the foreground.

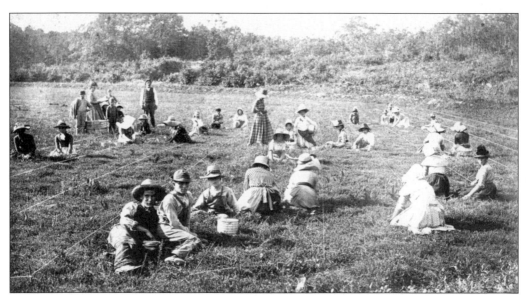

**PICKING CRANBERRIES IN SANTUIT, 1890.** Retired whaling captain John Harlow and Ebenezer Crocker built the Chopeboque Bog on the east side of Santuit Pond in 1876. Sold to James Brackett in 1910, it was later run by his grandson Philip Brackett of Cotuit.

ICE HAULING, 1912. Ice was cut on Lewis and Eagle Ponds and loaded onto ships above Handy Point. Horace Nickerson, the village iceman, stored it in this seaweed-insulated shed and delivered the 100-pound blocks by horse and wagon to the iceboxes of town. Summer grandees, such as the Lowells and Coolidges, had their own icehouses (still standing).

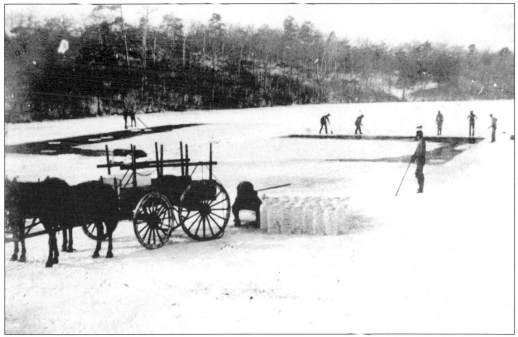

CUTTING ICE TO FILL THE ICEHOUSES, 1910. By midwinter, when pond ice was thick enough to support a team and wagon, men cut blocks of ice with long saws (middle distance) and brought them with hooks to the edge. The blocks were then pushed up a wooden ramp onto carts. (Courtesy of Alma Brackett.)

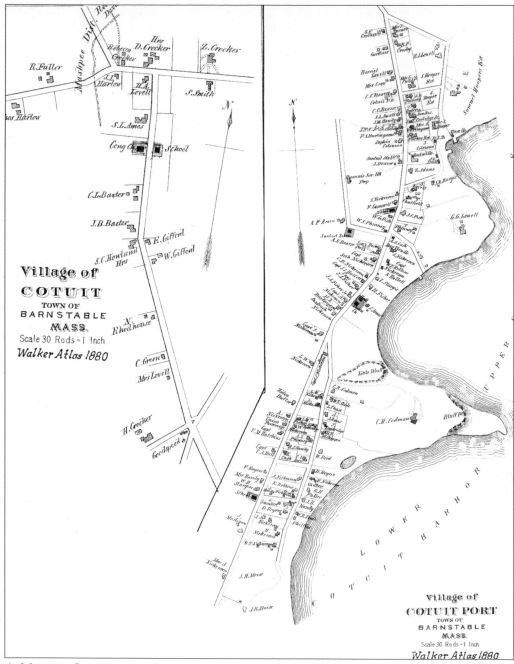

**A Map of Cotuit and Cotuit Port, 1880.** By 1880, there were two separate villages, although the postmaster had dropped the "Port" officially in 1872. There were also four schools by then. Stores were scattered conveniently throughout the village, and there was still no downtown concentration or buildings at Oyster Place (today's town dock).

# Four
# MOVERS AND SHAKERS

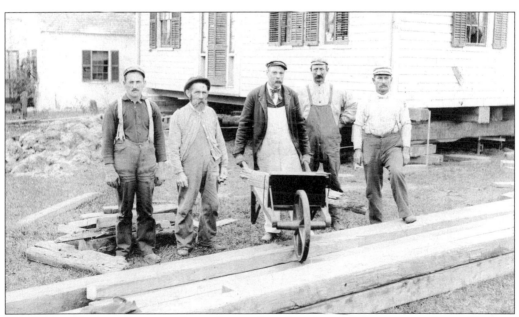

**FOOTLOOSE HOUSES.** So many Cotuit houses have been moved that one resident calls them "footloose houses." A succession of movers specialized in the trade: Otway Backus in the 1880s, Owen M. Jones (second from the left) *c.* 1900, Bob Hayden Sr. after World War II, and Bob Hayden Jr. today. Jones bought at least one surplus house in Nantucket, barged it across Nantucket Sound, and then dragged it by oxen or team of horses to the new site. (Courtesy of Laurie Bird.)

**THE VILLAGE PRINTER AND HIS WIFE.**
Willie Jones and his wife, Emma Manter, are shown in front of his print shop on School Street opposite Crocker Neck Road. In 1905, he moved this building from his birthplace next to Freedom Hall and repaired shoes and printed greeting cards here. He also made boat models that he sold out front to tourists passing by on the state highway.

**THE VILLAGE BLACKSMITH.** There was a big spreading shade tree in front of this blacksmith shop. Wesley Wright learned his trade from William Lewis, who had built this shop at 30 School Street in the 1870s. Wright took over the business, which he ran until 1909, when the automobile was already cutting into the need for horseshoes and iron fittings for wheels and wagons.

**BUILDING A COTUIT SKIFF, 1946.** Boats have been built here for centuries. Handys and Colemans built seagoing schooners in the 19th century. After World War II, Henry Chatfield Churbuck began building a new fleet of the Cotuit skiffs. He got the help of Merrill "Zeke" Crosby, shown here in the Churbuck boatshop at the back of Tom Chatfield's house. (Courtesy of David Churbuck.)

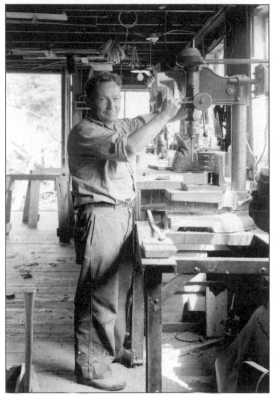

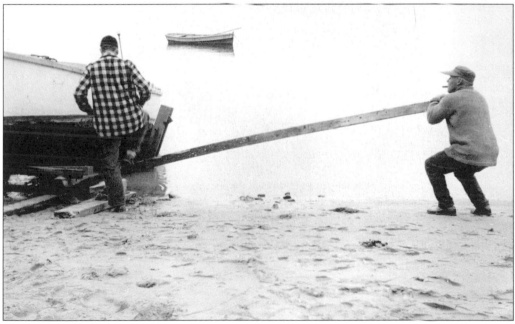

**TOM FISHER LAUNCHING A BOAT, 1938.** Boat launching has been done on the shore for centuries but is now done with mechanical slings and hoists. This is the traditional method. A cradle of wood encloses the boat. To lift it onto log rollers, a long lever is used. The boat can be rolled easily into the water or returned to land in the same way. (Courtesy of David Churbuck.)

**THE MORSE FAMILY PLAYHOUSE, 1918.** The Morses' red barn was the stage for plays and fairs, such as this 15th-birthday skit for Lucy Morse (front row, between her sister Bobbe, left, and cousin Sally). In the middle row are, from left to right, Frances Dunning and "Peanut," grandmother Lucy Morse, and her grandsons Billy Morse Jr. and Jim Dunning. In the back are, from left to right, grandfather James H. Morse, Marjorie, and William. (Courtesy of the Morse family.)

**CHIEF LEN HAMMOND AND NIECE, THE 1920s.** One of Cotuit's many Native American residents, Lorenzo "Len" Hammond followed his father Watson as chief of the Mashpee. A gifted artist, he invented the Victor Wellpoint (patented by a Cotuit plumber), a cranberry separator, and a bicycle brake. He is pictured with his niece Ethelind Pells at an early revival of the powwow. (Courtesy of Ernestine Gray.)

**CAPT. THOMAS CHATFIELD, 1864.** When the Civil War came, successful whaling captain Thomas Chatfield signed up with the navy. With the rank of acting master, he commanded ships blockading the Florida coast from Confederate runners and received high commendation for action under fire. The Mariners Lodge of Masons first met in his sail loft.

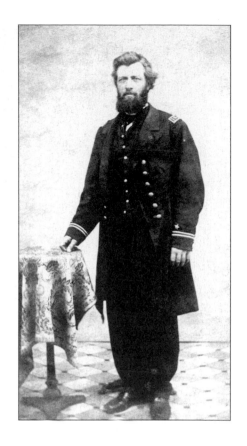

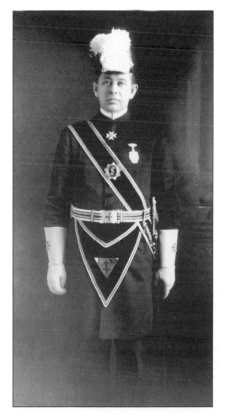

**THE MARINERS LODGE OF MASONS.** Asa Ellery Coleman is shown in his Masonic uniform. The lodge was started by a group of local sea captains in the house of Capt. Thomas Chatfield and, in 1870, moved to Freedom Hall, where it added a special hall to the top floor. When the Congregationalists gave up the Union Church in 1923, the lodge moved into that space for its permanent quarters.

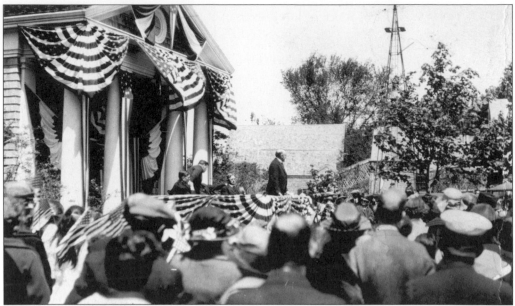

**Gov. Channing Cox Dedicating the War Memorial, 1923.** Guy Lowell's classical front of the library was a grand setting for the occasion of dedicating the World War I memorial. The bronze plaque honored the two Cotuit soldiers who made the supreme sacrifice during the war: Carleton Harlow (killed in France at the battle of the Aisne) and Ralph Hoxie (killed on a firing range at Chatham).

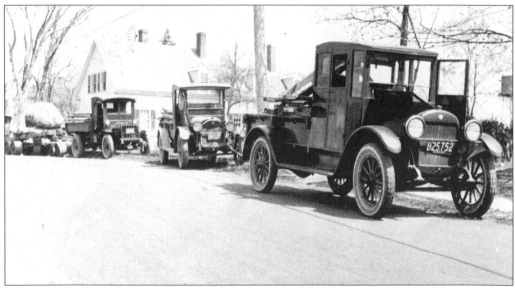

**Trucks on Main Street with the World War I Boulder, 1923.** It took three trucks in tandem to haul the huge boulder to the front of Capt. Thomas Chatfield's house. From here, it was moved across the street to the front of the library and was later moved to the park. The plaque reads, "This shall be written down for generations to come, Happy be he that repayeth ye as ye have served us." It names the 37 Cotuit men who served in the war.

**VILLAGE DOCTOR HIGGINS.** When he was 23 years old (in 1894), James Hayden Higgins took over the country practice of Dr. Pierce, riding by horse and buggy over sandy roads, which turned to deep mire in the spring thaw. Every baby born in Cotuit, Mashpee, and Marstons Mills was delivered by him until 1924. His son Dr. Donald E. Higgins took over the practice as village doctor. Their medical instruments are preserved in the Historical Society of Santuit and Cotuit.

**RALPH HOXIE, KILLED DURING THE GREAT WAR.** Ralph Hoxie (shown on the right with his buddies) was one of two Cotuit boys killed in World War I. The son of greenhouse gardener Everett Hoxie and his wife, teacher Etta Drew, he enlisted in the navy. He was sent to the naval training station in Chatham, where he was killed when he stood on top of a cranberry box to get a better view of the firing range. There is a monument boulder to him at junction of Putnam and Lowell Avenues. (Courtesy of Earlene MacDowell.)

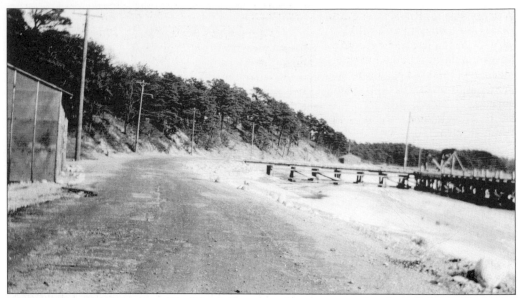

**WORLD WAR II IN COTUIT.** The North Bay waterfront was paved with asphalt, and four long piers were built into the bay. The first wooden landing boats were tried out here and used on mock landings on Popponesset Spit under cover of smoke. The army also tried out experiments in survival of sun exposure by putting volunteers out onto the water for long periods. (Courtesy of Peter Whittier.)

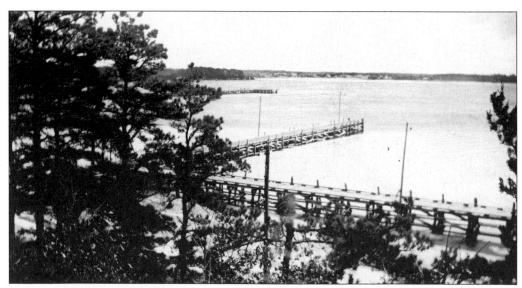

**CAPE COD COMMANDOS.** Three brigades of amphibious engineers trained at Camp Candoit on North Bay in World War II. The soldiers, called Cape Cod Commandos, trained at Camp Candoit and led the assaults on all the amphibious landings from the Solomons, New Britain, New Guinea, and Leyte. (Courtesy of Peter Whittier.)

**WORLD WAR II RATION STAMPS.** During the rationing of World War II, the hardest stamps to get were those for gasoline, so most summer folk did not get down to their Cotuit homes. Local people saved up for the rare trip to Hyannis and pooled rides to Camp Edwards, where many local men found work building barracks, and women worked as secretaries.

UNITED STATES OF AMERICA
OFFICE OF PRICE ADMINISTRATION

681929 **EN**

# WAR RATION BOOK No. 3

*Void if altered*

Identification of person to whom issued: PRINT IN FULL

*Lila          B.          Dottridge*
(First name)          (Middle name)          (Last name)

Street number or rural route *Lake St*

City or post office *Cotuit*     State *Mas*

| AGE | SEX | WEIGHT | HEIGHT | OCCUPATION |
|---|---|---|---|---|
| 50 | F | 150 Lbs. | 5Ft. 4 In. | House wife. |

SIGNATURE *Lila B. Dottridge*
(Person to whom book is issued. If such person is unable to sign because of age or incapacity, another may sign in his behalf.)

**NOT VALID**

### WARNING
This book is the property of the United States Government. It is unlawful to sell it to any other person, or to use it or permit anyone else to use it, except to obtain rationed goods in accordance with regulations of the Office of Price Administration. Any person who finds a lost War Ration Book must return it to the War Price and Rationing Board which issued it. Persons who violate rationing regulations are subject to $10,000 fine or imprisonment, or both.

OPA Form No. R-180

**LOCAL BOARD ACTION**

Issued by ............................................
(Local board number)          (Date)

Street address ............................................

City ............................     State ............

............................................
(Signature of issuing officer)    *Book II*

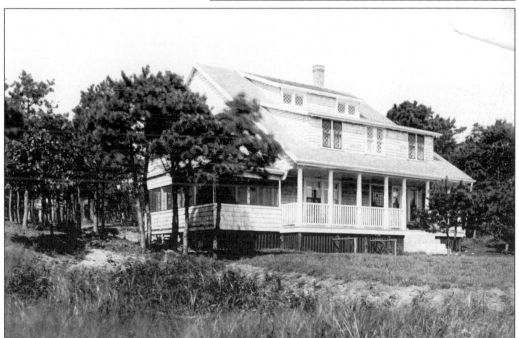

**THE OFFICERS CLUB AT CAMP CANDOIT.** The army engineers commandeered the Whittiers' summer home, Cedar Tree Landing, in 1942, paying them $1. This became the officers club, where local girls came to dance with officers to music played by a German prisoner of war. This cottage was built in 1911 by insurance man George York, whose daughter Margaret Whittier inherited it. (Courtesy of Peter Whittier.)

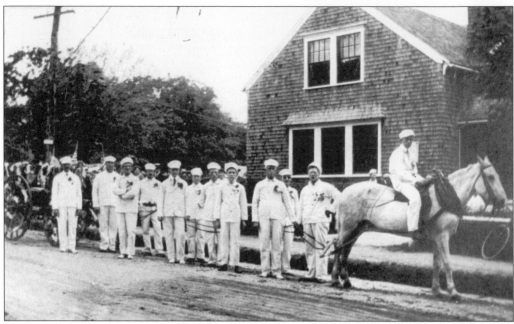

**COTUIT CHEMICAL COMPANY NO. 1, JULY 4, 1916.** Cotuit's first fire company consisted of 12 volunteers, shown here in front of the Methodist church. The chief, Seabury Childs, stands by the hand-drawn wagon with two 35-gallon drums of chemicals. This was the last year before the old wagon was replaced by the new LaFrance on a Model T engine.

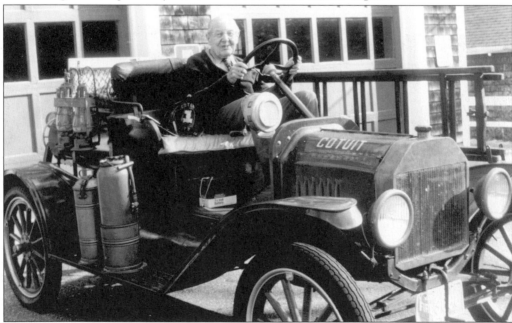

**CAPE COD'S OLDEST FIRE ENGINE.** In 1916, the Cotuit Chemical Company bought this Model T Ford, equipped by American LaFrance as the first motorized fire engine on the Cape. Here it is driven by Milton Crocker, who was first assistant engineer of the Cotuit Fire Company and ran the Coop, the local grocery store for half a century. The fire engine is on view at the museum of the Historical Society of Santuit and Cotuit. (Courtesy of the Cotuit Fire Department.)

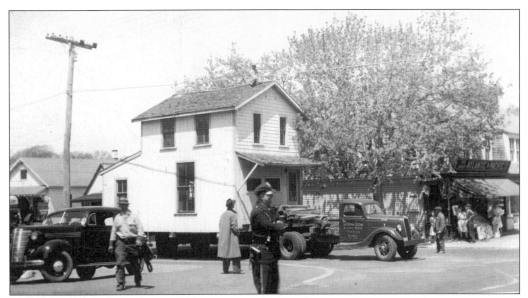

THE OLD FIREHOUSE MOVED TO SHELL LANE, 1938. Capt. Retire Sturges's store was originally next to the A & P on the corner of School and Main Streets and was moved to the present fire station. When it proved too small for the new brush breaker, Calvin Crawford bought it and had it moved to Shell Lane, as a home for Pines manager Arnold Lundquist. The mover was Morin and Company of Falmouth.

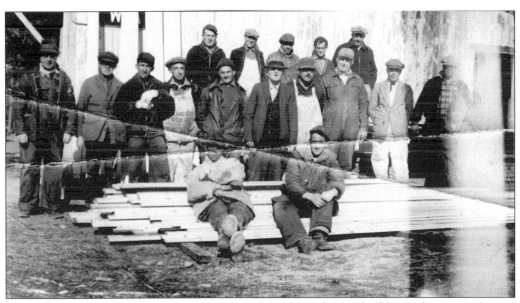

THE GREAT DEPRESSION HITS HARD, 1937. Although the building of summer homes continued after the stock market crash, it ended by 1934, not to resume until 1945. Prices of cranberries and oysters collapsed. The government came to the rescue with a public projects funded by the Work Projects Administration—the new waterworks, the repair of Freedom Hall, paving Falmouth Road, and (as seen in this photograph) the new fire station.

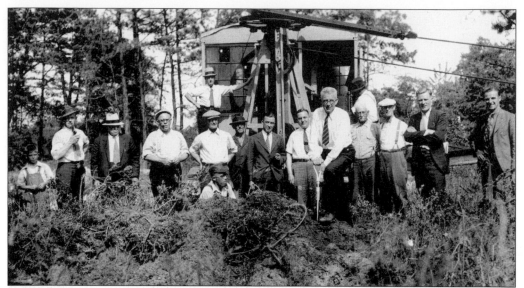

**COTUIT'S FIRST WATER, 1936.** In the summer of 1936, the fire district drilled the first well where Little River flows from Lovell's Pond. Present at the drilling were Prudential Committee members Milton Crocker (storekeeper), Calvin Crawford (hotel keeper), Ezra Gifford (oysterman), Seabury Childs (fire chief), William Perry Jr. (superintendent), Ernest Dottridge (water commissioner), and the engineers of the Public Works Administration (which gave $72,000 of the $165,000 project). (Courtesy of Earlene MacDowell.)

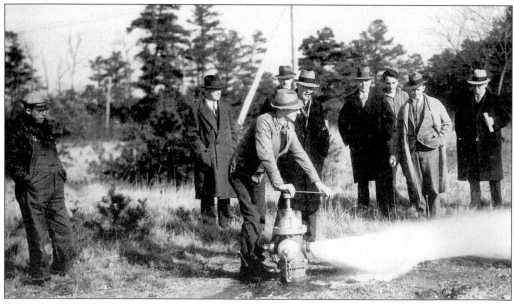

**COTUIT ANSWERS THE FIRE HAZARD.** After fires burned the Coop and Santuit House and damaged many homes, Cotuit at last had public water. In December 1936, the first hydrant was opened by William Perry (water commissioner), pictured here with fellow commissioner Ormand Dottridge and Prudential Committee member Calvin Crawford. Behind Perry are Public Works Administration officials. Also shown are Prudential Committee member Milton Crocker, Kenneth Turner (water commissioner), Maynard Gifford (clerk of the works), and Channing Howard. (Courtesy of Earlene MacDowell.)

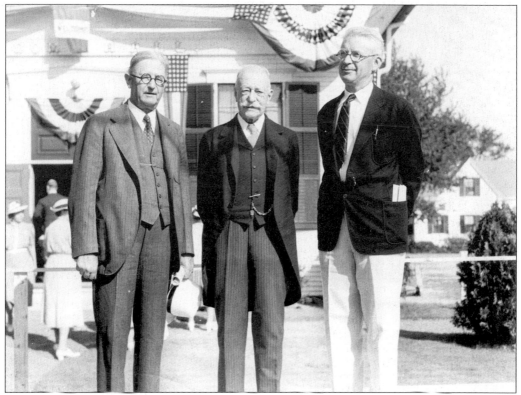

**COTUIT'S BIG THREE, JULY 18, 1938.** Three Cotuit notables are shown in front of Freedom Hall for celebration of the town's 300th anniversary. From left to right are Charles L. Gifford (U.S. representative), Harvard president Abbott Lawrence Lowell (with Phi Beta Kappa key), and Calvin Crawford (chairman of the event, chairman of the Cape Cod Chamber of Commerce, and manager of the Pines Hotel).

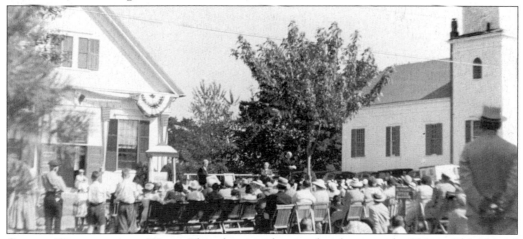

**COTUIT TERCENTENARY WEEK.** This photograph was taken between the Union Church and Freedom Hall on July 18, 1938. Calvin Crawford, chairman of the Barnstable Tercentenary Committee for Cotuit, is standing, about to introduce the chairman of the meeting, native son Congressman Charles L. Gifford. To the left of Crawford is Abbott Lawrence Lowell, summer resident of 70 years.

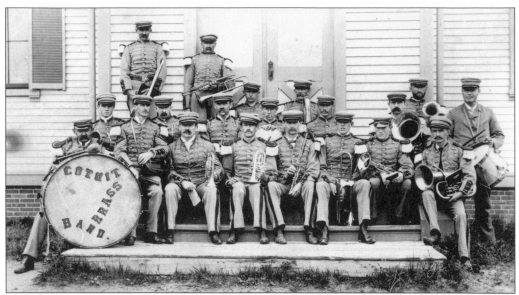

**THE COTUIT BRASS BAND, C. 1895.** From left to right are the following: (front row) Bill Harlow, bass drum; Wally Ryder, piccolo; Ernest Nickerson and Albert Grigson, trumpets; Gus Nickerson, clarinet; Russell Childs, trombone; Ulysses Hull Jr., horn; and Ben Crosby, baritone; (middle row) Ernest Childs and Wesley Wright, trumpets; Seabury Childs; Julius Linnell; Zenas Crocker, clarinet; Charles Fuller, bass horn; and Ulysses Hull, drum; (back row) William Childs and Thomas Fuller, trombones; Harry Fuller; Fred Savery, tuba; and Howard Goodspeed, trombone.

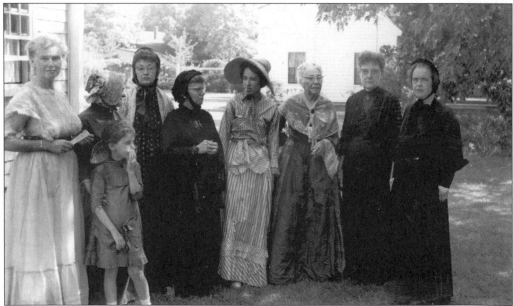

**THE FOUNDERS OF THE HISTORICAL SOCIETY.** The dedication of the Samuel Dottridge house in 1964 was the occasion for the dressing up by the women who had founded the Historical Society of Santuit and Cotuit in 1954. From left to right are Peggy Ball, historian Florence "Floss" Rapp Shaw, her granddaughter Jessica Rapp, Janet Rose, Helen Matthews Dottridge (longtime president), Elizabeth Kenna, Nita Morse Crawford (the dynamic owner of the Pines), Marion Meyer, and Gwen Crawford.

# *Five*

# SANTUIT

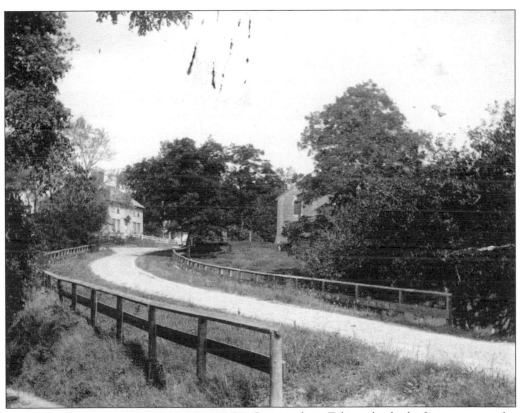

**FALMOUTH ROAD IN SANTUIT, THE 1920S.** Coming from Falmouth, the highway crosses the Santuit River, with the Sandwich Road (Route 130) coming in from the left next to the Ebenezer Crocker House (the oldest in Cotuit), brought here by oxen from West Barnstable in 1749. The road was not paved until 1934, but to keep the dust down, it was oiled and graded by town road engineer Zenas Crocker, who lived nearby.

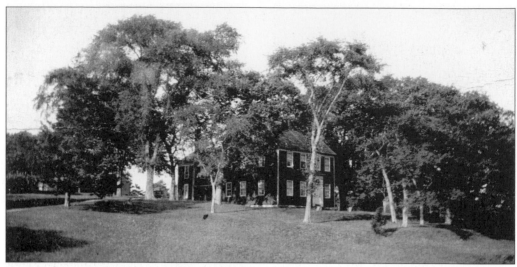

**THE SECOND COTUIT POST OFFICE, 1840.** Rev. Phineas Fish ran the Cotuit post office in his family homestead, a post-and-beam house built in 1712 just over the town line in Sandwich. Here, we see it at the back part of James Brackett's house. The building later became Carter Whitcomb's mansion Cranberry Hill and, finally, the Dare School that burned down in 1978.

**COTUIT MUSICIAN MARY SAMPSON CROCKER, C. 1910.** Pianist Mary Sampson Crocker, Cotuit's most noted musician, accompanied singer Mary Garden on her concert tours. Born in the Crocker farmhouse, Crocker was daughter of civil engineer Benjamin Sampson Crocker, who had gone to the Northwest to lay out railroads. He was the last man of the Crocker-Sampson line who had lived in this location since the 1600s. Mary Sampson Crocker, who never married, ended that distinguished line.

REBECCA SAMPSON AND ZENAS CROCKER JR., C. 1865. Zenas Crocker Jr., a wealthy landowner, inherited his grandfather Ebenezer Crocker's house. His marriage to Rebecca Hawley Sampson, granddaughter of Rev. Gideon Hawley and niece of the childless Squire Sampson, brought together four Colonial families, including Zenas Crocker Jr.'s mother's family, the powerful Bournes. (Courtesy of Zenas Crocker.)

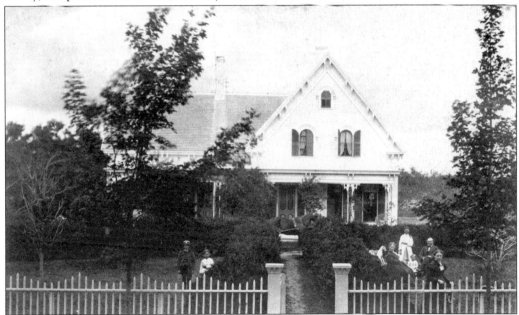

THE ZENAS CROCKER III FAMILY IN SANTUIT, C. 1874. Sitting in front of the Italianate-style house he built with Gold Rush money in 1861 are Zenas Crocker III and his wife, Susan Jones, with son Francis between them, Ellen behind, Hattie in front, and on the far left, Zenas Crocker IV (left) with a friend. (Courtesy of Merle Crocker.)

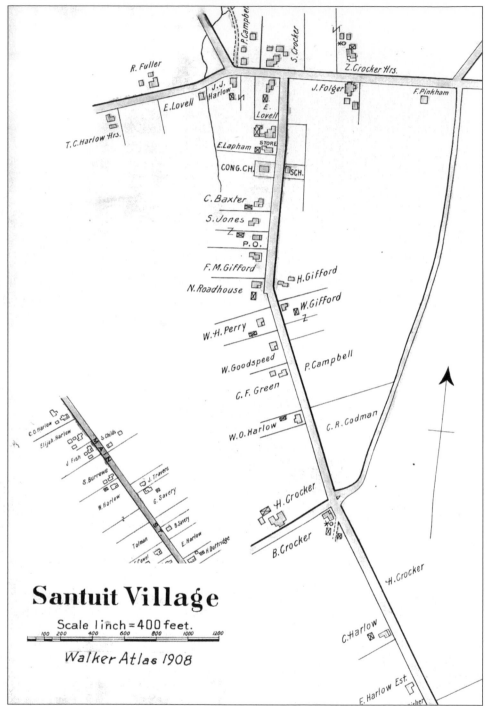

**A SANTUIT MAP, 1908.** Santuit and Cotuit, which had been the same, were first distinguished in 1892, when the post office was created at the location shown here. By 1908, the village was still dominated by the founding Crocker family, but it had expanded southward in Harlow Row and had its own general store. The first Portuguese proprietor, Joseph Folger, had a tavern in the old Roland Crocker store, marking the start of the Portuguese community east of his tavern.

52

THE ROLAND CROCKER STORE. A fine Federal-style mansion was built in 1796 for Roland Crocker, oldest son of Alvan Friday. Soon after it was built, Roland opened the first library here. Although he had no children, he gave the land at the back of the house for the first school in 1793. When a stage route between Barnstable and Falmouth was established in 1821, he opened the first post office here. He also sponsored the first church (in 1846).

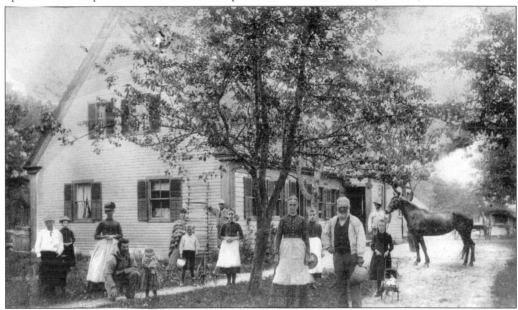

THE GIFFORD FAMILY AT THE HOMESTEAD, C. 1889. This photograph shows the extended family of grandparents Edward Gifford and Marion Jones of Marstons Mills. He was born as William Matthews to Ruthy Matthews, the unmarried housekeeper of Edward Matthews. In 1850, the old Abner Crocker homestead (perhaps dating from as early as 1808) was moved by oxen to Santuit, where it stands at 134 Main Street. Here, Edward Gifford had his cooperage shop and farm. (Courtesy of Earlene MacDowell.)

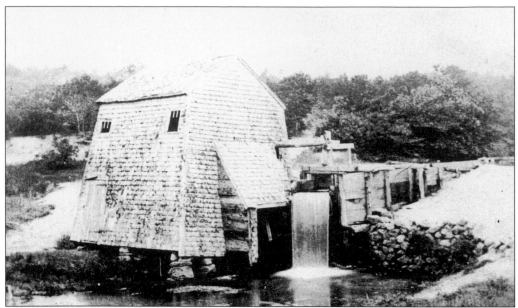

**SAMPSON'S GRISTMILL ON THE SANTUIT RIVER.** For 200 years, this was where villagers and neighboring Mashpee Indians had their grain ground for their daily bread. The first mill was built here in 1690 and was used by the pioneer Crocker families. By the 19th century, it had been inherited by the Sampsons. It was operated until 1890, when factory-made flour drove home mills out of business.

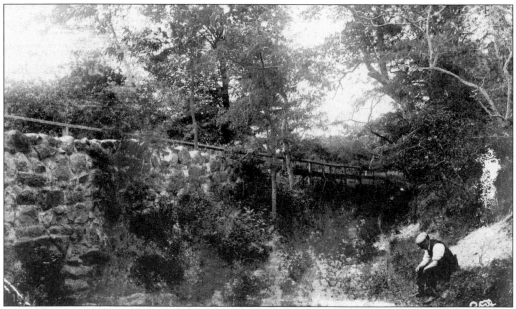

**A BRIDGE OVER THE SANTUIT RIVER, SEPTEMBER 1904.** Santuit River, or Cotuit Brook, is a fine herring run and brown trout stream. According to ancient Wampanoag legend, the streambed was created when the Great Trout heard the song of the Lorelei maiden and forced his way upstream to woo her. The main post road from Falmouth to Barnstable originally crossed at a Native American fording place, replaced by this substantial stone bridge. (Courtesy of Jean Crocker.)

**THE CROCKER TAVERN.** At the head of Main Street, the fourth-oldest house in Santuit was built in late-Georgian style in 1782 by the first Zenas Friday Crocker. In 1821, his son Ezra opened a tavern where Yale president Timothy Dwight and Sen. Daniel Webster lodged. Ralph and Martha Cahoon had their art studio here, now the Cahoon Museum of American Art. (Courtesy of the Cahoon Museum of American Art.)

**SAMPSON'S FOLLY.** Long the biggest house in Cotuit, this classic Federal-style mansion was built in 1807 by Squire Josiah Sampson, heir to the rich farmlands of the Crocker family nearby and the Sampson gristmill on the river. The house included a ballroom on the second floor, as well as the area's first indoor bathroom. In later years, it served as home of two successive presidents of the Historical Society of Santuit and Cotuit, who ran it as a bed-and-breakfast.

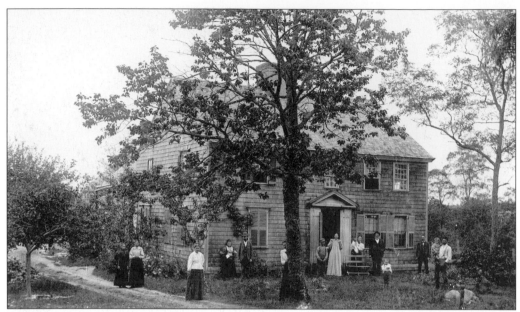

**THE ALVAN FRIDAY CROCKER HOUSE.** This is the third-oldest house in Cotuit, built in 1769 for the wedding of Sylvia Thatcher, daughter of Rev. Roland Thatcher of Wareham to Alvan Friday Crocker, oldest son of Ebenezer Crocker. Alvan's middle name came from the day of the week he was born, like all of the Crocker children. Out front is the family of Susan Percival, the wife of John Harlow, a longtime town constable, retired whaler, and successful cranberry farmer.

**BAXTER'S BARREL FACTORY, C. 1880.** Next to the John Baxter house, housewright Charles Baxter made barrels for the Cotuit oysters and cranberries. Chips were so abundant that they were carted over to "Shave Hill" on the Falmouth Road to help wagons get up the steep hill. John Baxter and his wife, Josephine, are shown with their daughter and grandchild. Barrel making continued in Santuit until 1949, after a century of production.

**SCHOOLTEACHER EDWARD BEARSE.** This Santuit scholar always wanted to be a teacher and found his dream fulfilled at 19, when he was appointed to the Newtown Grammar School. In 1901, on a cool May Day, he gathered arbutus in a basket to lay on the doorstep of his sweetheart. Hiding in the neighboring swamp to await her reaction, he caught cold and died of pneumonia. The Newtown Grammar School closed forever, but the building still stands on School Street in Newtown. (Courtesy of Earlene MacDowell.)

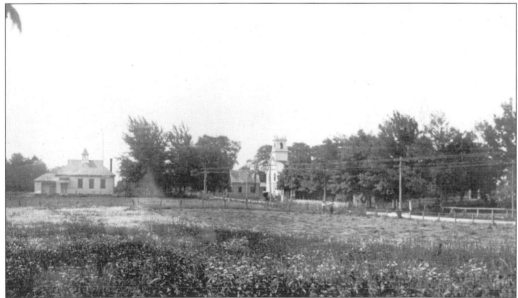

**THE CENTER OF SANTUIT, C. 1908.** Looking down from Falmouth Road across an open hayfield, we see the third Cotuit school on this site, where the Portuguese children learned English alongside Yankee and Native American children. On the west side of Main Street is the Cotuit Congregational Church, built in 1846 by Rev. Phineas Fish (missionary to Native Americans), and the home of builder John Baxter (to its left).

**THE FOUNDERS OF THE OLDEST PORTUGUESE SOCIETY.** Shown shortly before moving from New Bedford to Santuit in 1904, Manuel Sousa had brought his bride from St. Michael's Island in the Azores. Mary Mercedes Botelhio Matias joined her parents in Santuit. Her mother, Jennie Cabral Matias, had brought with her a replica of the crown of the Holy Ghost and started one of the oldest Portuguese societies in America. (Courtesy of James Souza.)

**THE CROWN OF THE HOLY GHOST SOCIETY.** The Feast of the Holy Ghost is celebrated on Pentecost Sunday in June. The crown of the Queen Isabel of Portugal celebrates the peacemaker saint who fed the poor. This one is a replacement for the original tin crown brought to Santuit by Jennie Cabral Matias in 1902. The Holy Spirit is represented by the dove in the pink cushioned banner below and at the end of the scepter under the crown. (Courtesy of the Holy Ghost Society.)

**THE JOHN ROGERS FAMILY, 1913.**
John Rogers, carriage maker and
wheelwright in the Azores, married
local schoolteacher Maria Henrietta
Robello. His nephew Ernest had just
arrived. The two older girls, Maria
Mercedes and Maria Carmen, came to
America with their parents in 1898 and
to Santuit in 1903, where Maria of the
Angels (left) was born and died of
diphtheria shortly after this photograph
was taken. Mary Myra was five.
(Courtesy of Charles Hamblin.)

**PURITANS AND PORTUGUESE.** The two Rogers sisters, Maria Carmen and Maria Mercedes,
came with their parents from the Azores to Santuit in 1903, married the Hamblin brothers of
Newtown, descendants of original settlers of the area in 1600s. Here is Seth Hamblin in 1919,
when he married the younger sister of Maria Carm, who had married his brother Charles in
1916. (Courtesy of Mr. and Mrs. Seth Hamblin.)

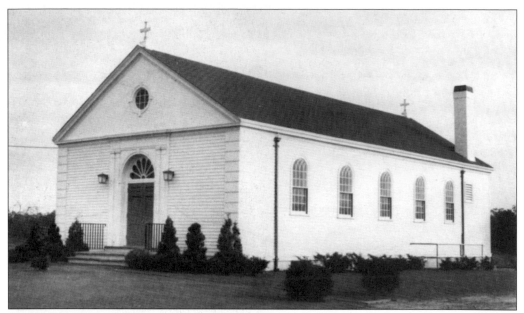

**ST. JUDE'S CHURCH.** Jennie Cabral Matias gathered friends for worship in her home and, later, in the old Santuit schoolhouse. In 1939, her grandson Frank Frazier donated land next to the Matiases' and helped build the first Catholic church in Cotuit. It was moved by Bob Hayden to the Christ the King church in Mashpee in 1988. However, a thrift shop and a convent remain next to the site.

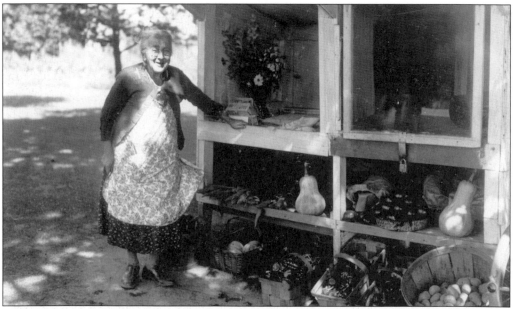

**MARY ROBELLO AND THE BOUNTY OF THE SOIL.** Portuguese immigrants had been great farmers in their native Azores and turned the rich loam of Santuit into productive truck gardens. Pictured at her roadside stand on Main Street is Maria Homen Rodrigues, born on the island of Pico in 1898. At age 13, she came to New Bedford and, in 1918, married farmer Antone "Tony" Botelho Robello. They raised the four stars of the Cotuit ball team—John, Manny, Victor, and Joe.

**TWO PIONEER FAMILIES UNITED.** Sylvia Maderios was only 15 when she got permission to marry Manuel Santos Enos, who was 26. Because there was no church here, the service was held at St. Francis Xavier in Hyannis. The ceremony united some of the St. Michael's Island families who founded the Holy Ghost Society in Santuit—Enos, Frazier, Maderios, and Reposa. (Courtesy of Charles Hamblin.)

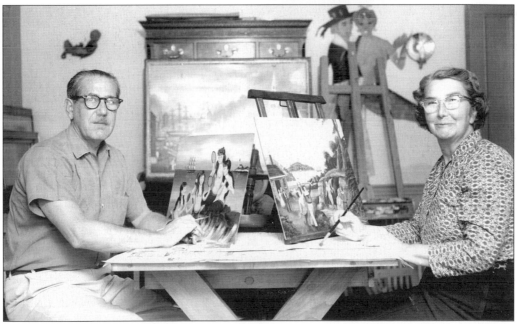

**RALPH AND MARTHA CAHOON.** This couple began painting furniture in primitive style before World War II. His mermaids and sailors achieved such popularity that he was commissioned for murals as well as oil on canvas. Today, their work is on view in their former studio home, in the Crocker Tavern, maintained by the Cahoon Museum of American Art. (Courtesy of the Cahoon Museum of American Art.)

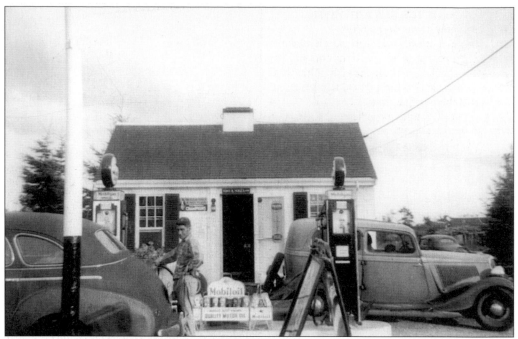

**A SANTUIT GAS STATION, 1938.** Tony "Hawk" Souza pumps gas at his filling station on the corner of Newtown Road and Route 28. His nickname came from his noble aquiline features. He took over the Mobil station from his brother-in-law Richard J. Anderson. After World War II, Souza reopened it as a Texaco station, which he and his wife, Doris, ran until 1955, when they moved the station across the street, where it is still pumping gas.

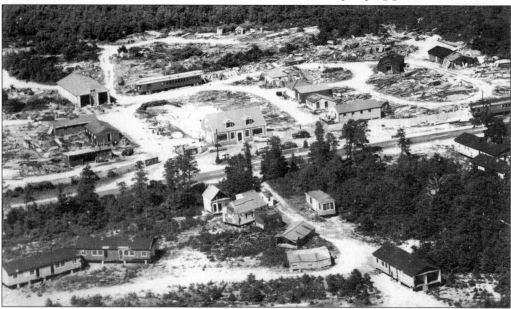

**TREASURE HIGHLAND, 1954.** Bob Hayden Sr. of Cotuit became the Cape's busiest mover. Cape Colony railway cars and abandoned buildings, many from Camp Edwards, were stored on both sides of Route 28 at his Treasure Highland, now the Stop & Shop. The only building still there is his office (in the center), now the Fleet Bank. (Courtesy of Cynthia and Bob Hayden Jr.)

**THE MOUTH OF THE SANTUIT RIVER.**
This photograph was taken after
Rep. Charles Gifford of Cotuit got the state
to build the bridge in 1916. Remnants of
the old footbridge are in front of it. This is
the town line, with Mashpee on the left
and Barnstable on the right. Here, the
Great Trout of Wampanoag legend began
his push up river to the romantic call of
Native American maiden Ahsoo.

**THE APPROACH TO THE BRIDGE AT SHOESTRING BAY.** To create the state highway from
Mashpee to the bridge over the Santuit River, the builders had to cut off this slope. The road,
now called Quinaquisset, was originally called Gifford Road for the state senator from Cotuit
who got the project through in 1916 (and who, incidentally, owned the land shown here, which
he called Cotuit Park). (Courtesy of Alma Brackett.)

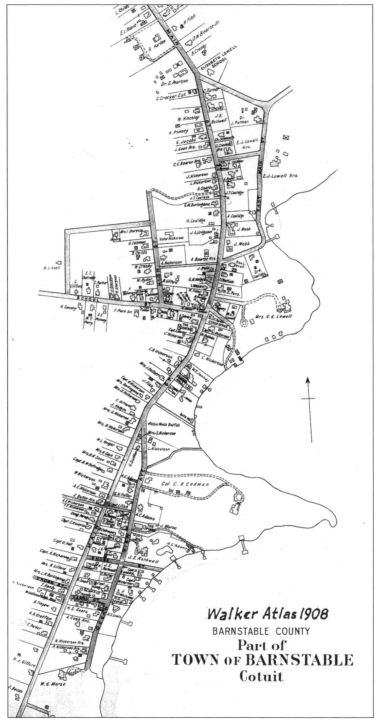

Walker Atlas 1908
BARNSTABLE COUNTY
Part of
TOWN of BARNSTABLE
Cotuit

**A Cotuit Map, 1908.** This map shows every house in the village, as well as the high school, three churches, and three hotels. The big changes since 1880 are the new commercial center around School Street, the coal and lumber wharf at Oyster Place, and the new homes on High and School Streets. Most of the new piers were seasonal.

64

# *Six*
# MEETING PLACES

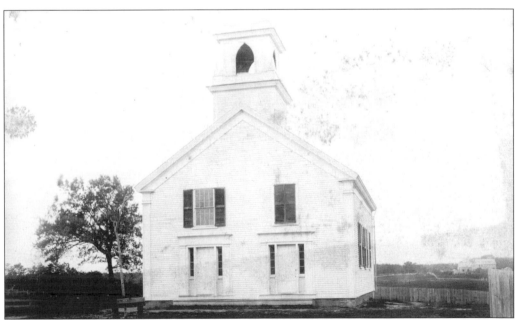

**FIRST CHURCH OF COTUIT.** Later called the Santuit Meetinghouse, this structure was built on upper Main Street in 1846, when Cotuit Port and Cotuit (today's Santuit) decided to build separate churches. Beyond the river to the right is the Thomas Harlow house. The first minister was Rev. Phineas Fish, who had been evicted from the Native American church by the Mashpee congregation but retained some Native American parishioners. Derelict by 1942, it was demolished by Bob Hayden Sr.

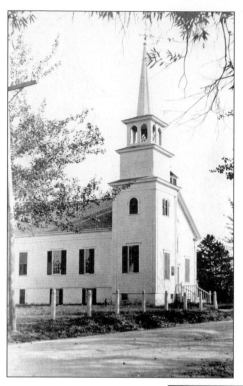

**THE UNION MEETINGHOUSE.** The oldest community church in America, this building was constructed in 1846 by three denominations—Congregational, Baptist, and Methodist. A similar Greek Revival church was built at the same time two miles north in Cotuit (today's Santuit). Methodists broke off to build their own church in 1901, and Congregationalists rejoined them in the Federated Church in 1924. The remaining parishioners sold the building to the Mariners Lodge of Masons.

**FREEDOM HALL AND THE UNION CHURCH.** This photograph shows a family gathering in front of the Union Church some time after the basement and steeple were added in 1872. Beside the Union Church is Freedom Hall, built by subscription in 1860 as a "suitable place for all well-disposed persons to assemble in, hold meetings, lectures, assemblies, parties, lyceums, etc.," as its charter declares. This has been the center of village social life, for weddings, musicals, movies, art exhibits, dress balls, political debates, musical concerts, auctions, and elections.

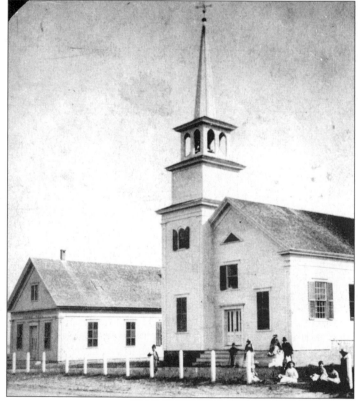

THE METHODIST EPISCOPAL CHURCH, 1901. Methodists finally broke with the Congregationalists in the Union Church and had Lonnie Savery build this church for $5,000 on the corner of School and High Streets. Architect K.H. Allen designed this lovely Victorian building in the Queen Anne and Shingle styles. By 1941, this had become old fashioned, and Rev. Walter Kraft's congregation had it transformed into the present Colonial Revival style.

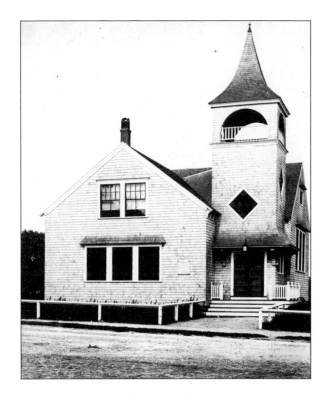

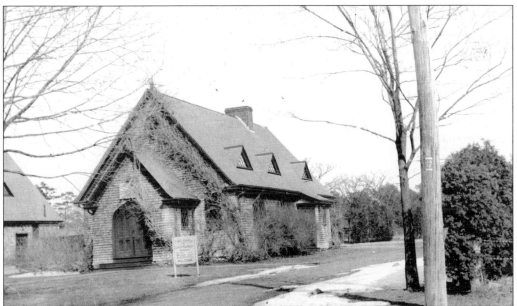

THE CHRISTIAN SCIENCE CHURCH. This church, on the east side of Main Street above the Coop, was built in 1902, probably by Howard Dottridge, whose wife, Lizzie, was one of the founders along with Cynthia Handy and others. In 1949, it was moved 10 miles east to Bearse's Way in Hyannis, where it is still used for services. In 1930, the Christian Scientists added a summer annex just south of the church on Main Street. This, too, was moved to Hyannis, where it is attached to the main building.

**THE FIRST CHURCH OF CHRIST, SCIENTIST.** The church is shown at the dedication on October 7, 1906, after all the debt was paid off. The interior, which seated 100, was decorated by Everett L. Hoxie, proprietor of a Cotuit greenhouse. Hoxie grew these plants in his hothouse on the north side of the road to the present Cotuit School. (Courtesy of Earlene MacDowell.)

**THE CARRIAGE SHED AT THE CHRISTIAN SCIENCE CHURCH, 1906.** In this view, a two-seated surrey has brought Christian Scientists to the church. Across Old Orchard Field (now Ropes Field) is the Capt. Andrew Lovell House when it was occupied by the first psychiatrist in America, Dr. James Jackson Putnam, and his family, after whom Putnam Avenue is named.

**ELIZABETH LOWELL HIGH SCHOOL.** Cotuit's high school, built in 1906, sent more graduates to normal school than Hyannis did. Both the building and the land were donated by summer resident Elizabeth Jones Lowell, daughter of the founder of the New York Times. It started in 1892 in the old Santuit School, where the post office is today. One teacher was future U.S. Congressman Charles L. Gifford. When the high school building was torn down in 1937, some timbers were put into the fire station.

**ELIZABETH LOWELL.** The home of the Cotuit Kettleers on Lowell Avenue commemorates Elizabeth Lowell, the donor of both land and building for the high school. Born Elizabeth Gilbert Jones, she married historian Edward J. Lowell and raised his three children—Alice, Guy, and Frederick. She died in 1904. (Courtesy of Roger Barzun.)

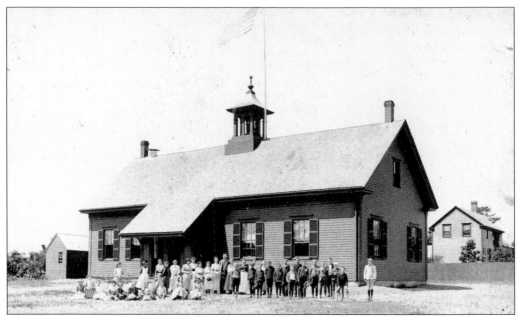

**SANTUIT GRAMMAR SCHOOL, 1891.** The names Santuit and Cotuit are interchangeable, so this school was built on the site of the present post office. A one-room school was built here by villagers in 1867 and was enlarged many times, keeping the same cupola and school bell that rang the alarm for fires. Valentine Almy of Cranston, Rhode Island, was principal of Cotuit High School in 1890–1891. Grammar school was taught for a decade by Lizzie Lovell (at the doorstep). (Courtesy of David Churbuck.)

**THE SCHOOL PLAYGROUND.** Behind the school was a frog pond, which had the best-educated frogs in town, since they went to classes in schoolboys' pockets. The pond was filled in to create a fine playground behind the school, big enough for two baseball diamonds, the nearer one for girls. The building gave its name to School Street, which quickly lined with new homes of local businessmen and their children.

**LUCY GIBBONS MORSE.** The daughter of Quaker abolitionists, Lucy Gibbons Morse came to Highground with her husband, James Herbert Morse, in 1878 and summered here until her death in 1936. She founded the Cotuit Library in 1885. She was a gifted artist, and her woodcarving adorns the Cobb house. Many summer homes had lamps with her silhouettes of fairies and pixies in the Cotuit pitch pines. (Courtesy of the Cotuit Library.)

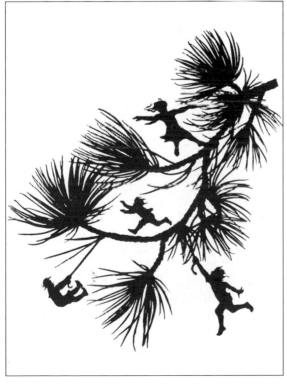

**LUCY GIBBONS MORSE'S PIXIES.** These scissor cutouts were often based on tricks played by Lucy Morse's own children and grandchildren. In one, a grandmother scolds a defiant imp. The silhouettes became popular for lampshades, and the Lowells loved them so much that they ordered a set for the dining room of a Harvard house for students. (Courtesy of the Cotuit Library.)

71

**THE SECOND LIBRARY BUILDING, 1885.** Lucy Gibbons Morse led the village in its search to find a building for a permanent library (the first had been in the Roland Crocker store in Santuit) and to improve the collection of the Lyceum Society in Asa Bearse's store. This building was located conveniently behind Freedom Hall but soon outgrew the space.

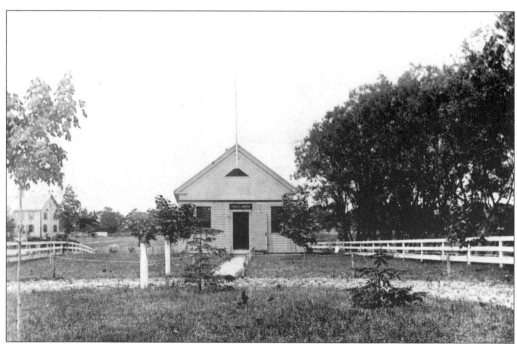

**THE THIRD COTUIT LIBRARY.** In 1895, the Library Association bought the old District 11 Schoolhouse from the town for $800. Now the core of the present library, this had been built on Main Street in 1830, as the first school in Cotuit Port. Cotuit High School was moved from here across Cotuit Park to the new two-story Santuit School (left), on School Street.

**THE SOAP KING AND BENEFACTRESS OF VILLAGE.** Sidney Kirkman, the wealthy head of the "Gold Dust Twins" soap company, summered in the Codman mansion on Bluff Point. The will of his widow, Mary, left a large bequest to the town of Cotuit (although there was no such thing) for Mosswood Cemetery and the library. The town of Barnstable won the suit and spreads the bequest among all 7 libraries and 13 cemeteries.

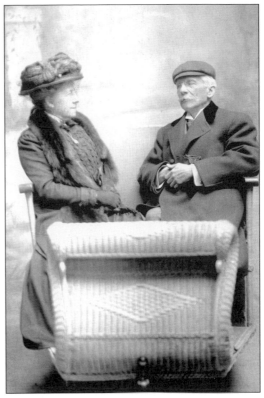

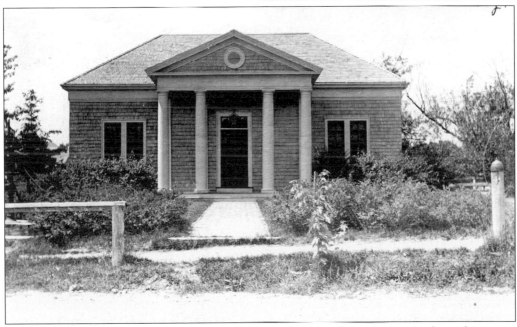

**GUY LOWELL'S LIBRARY BUILDING, 1901.** The old schoolhouse was transformed into an imposing Classical building with four Ionic columns facing Main Street. The architect was the famous designer of the Boston Museum of Fine Arts and other public buildings, Guy Lowell, who had grown up in Cotuit.

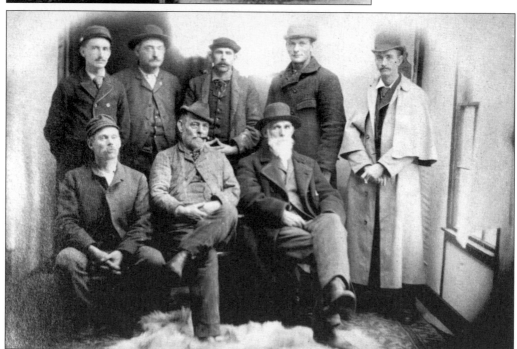

**COTUIT MOVIES, 1915.** Freedom Hall was a popular place for silent movies, six of which are advertised out front, with a sign reading, "Show Tonight." Piano music to fit the mood of the action was played by Nellie Sturges Smalley, and the projector was run by Ernest Dottridge. (Courtesy of Henry Walcott.)

**A GATHERING OF DEMOCRATS, 1882.** When Grover Cleveland won the election of 1884, Democrats made Augustus Thorndyke Perkins's governess Addie Bearse Cotuit postmistress. In 1888, however, Republicans won the presidency, and the Republican postmistress Lizzie Lovell was back in office. Cleveland won again in 1892, bringing back Bearse. The battle was not settled until 1896, when William McKinley's Republican Lovell came back for good.

*Seven*

# THE NARROWS
# TO LITTLE RIVER

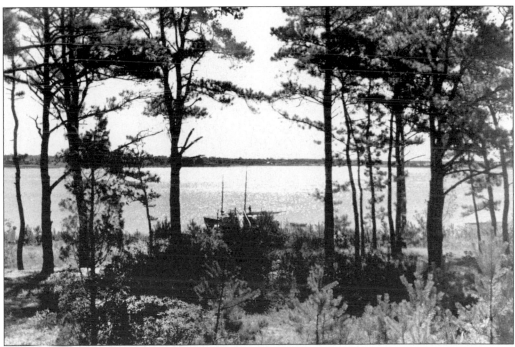

**CEDAR TREE LANDING ON NORTH BAY.** North Bay sparkles in the morning sun, with Osterville in the distance. In swamps nearby, Atlantic white cedar was cut for shipbuilding and was shipped from a dock that marks the line between Cotuit and Marstons Mills. The York-Whittier house lies on the Cotuit side of the line, but everyone north of it went to Cotuit for mail. (Courtesy of Peter Whittier.)

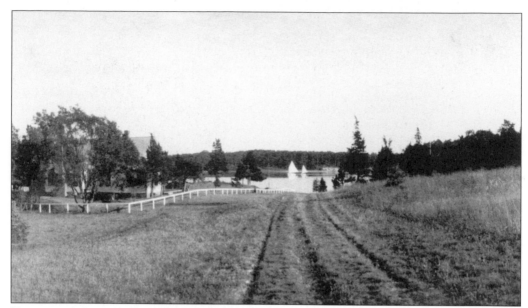

**TALLMANS' CEDARVILLE AT POINT ISABELLA, C. 1910.** This view looks east to the Narrows from the Tallman farm, which lay near "Old Chalky," where middens of oyster shells were burned for lime in Colonial days. Stephen Tallman carried the mail between post offices until he was killed by a fall from a carriage along a road. (Courtesy of David Churbuck.)

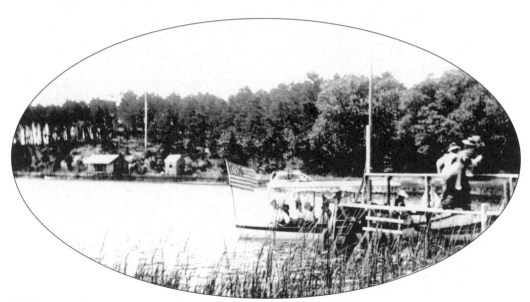

**A SUMMER EXCURSION FROM POINT ISABELLA.** Ladies in hats and long skirts are returning from a boating excursion coming home to the Dupee Pier in the Cowyard on the south side of Point Isabella. On the far shore are the boathouses of Judge Charles Almy below their summer home the Narrows, named for the straits between Cotuit and Grand Island. (Courtesy of Frances Parks.)

**CHARLES C. BEARSE.** Moderator of all village squabbles, Charles C. Bearse was a real genius. A self-trained architect, he built the first mansard-roofed house in the village for Boston brahmin Augustus Perkins. Bearse established the name Cotuit where it is today by changing the name of the post office in his general store (in the present Coop) from Cotuit Port. He was also state representative, county sheriff, and town selectman and assessor.

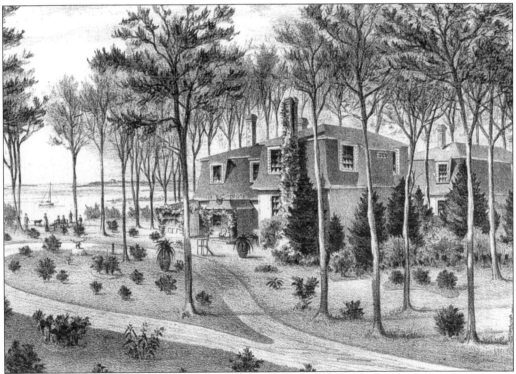

**SANDANWOOD, 1880.** When this first Cotuit summer home was built in 1863, it marked the start of the resort era. Heir to an East India trade fortune, Augustus Thorndyke Perkins had local architect-builder Charles C. Bearse build this fine mansard-style house, setting the fashion for Cotuit to have more of this style than any place on the Cape. Perkins's daughter added a lovely Japanese garden.

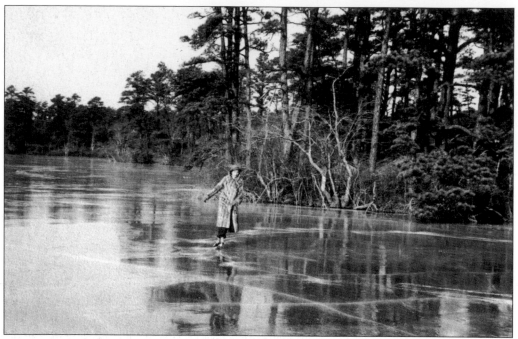

**ELIZABETH BARTON ICE-SKATING ON EAGLE POND, 1936.** The last eagle in the region was seen here in 1952. More than 100 acres of woodland were preserved by Augustus Thorndyke Perkins, who allowed townspeople to drive their buggies along the shady roads. Saved from development by the will of Mary Lowell Barton, the area is now preserved for public enjoyment by a conservation trust named in her honor. (Courtesy of Francis Barton.)

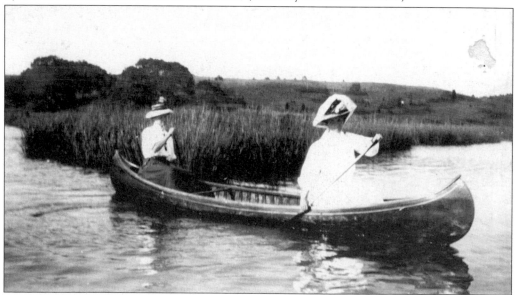

**CANOEING IN COTUIT.** Caroline Dupee Nazro (right) and a friend have a happy paddle from Caroline's home at Point Isabella, which was named for her mother, the wife of Boston chemical manufacturer Henry Dupee, who came to the area in 1895. At that time, he was an agent of Keiths Theaters, including the magnificent Moorish-style theater on Tremont Street in Boston. (Courtesy of Frances Parks.)

**ELIZABETH GREENE PERKINS, C. 1899.**
Elizabeth Greene Perkins, the daughter of
Augustus T. Perkins, grew up at the summer
mansion Sandanwood and was married there
in 1901 to William Wadsworth of Geneseo,
New York. In 1905, she built her own
summer home, Tecumic, named for a
legendary Native American chief. This
Mediterranean-style house had huge rooms,
warmed by grand fireplaces. (Courtesy of
Sarah Wadsworth Wood.)

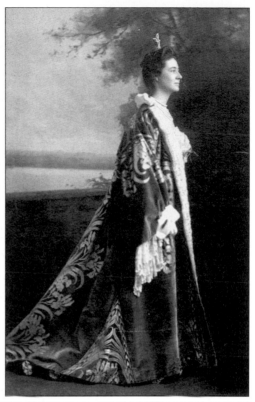

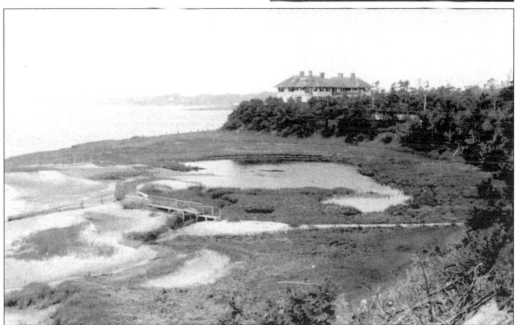

**TECUMIC ON MUMMICHAUG POND.** The 1905 Wadsworth mansion is on the south side of
Mummichaug Pond. From where this photograph was taken, eminent neuroscientist Dr.
Stanley Cobb observed the decline in birds and the fish on which they fed. He first alerted the
world to the dangerous effect that DDT was having on wildlife. (Courtesy of Stan Solomon.)

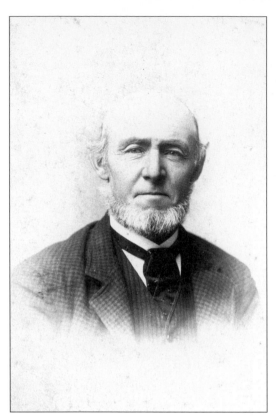

**AN ARCTIC RESCUER.** Capt. Bethuel Handy's whaling ship was caught in an early freeze of ice in the Arctic Ocean. Knowing they could not survive a winter, Handy abandoned the full cargo of precious whale oil and led his crew of 32 across the ice, through 7-foot drifts to the shore, 40 miles away, to reach a Russian military outpost in Siberia, without losing a man. (Courtesy of David Churbuck.)

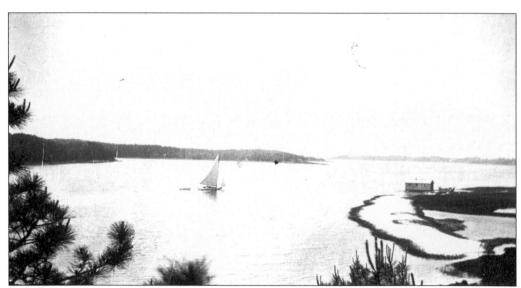

**THE HARBOR SEEN FROM THE NARROWS, 1913.** A large pleasure yacht, perhaps the Cobbs' sloop *Pamaho,* sails down the Narrows past Ezra Gifford's oyster house, which harvested the richest oyster beds in Cotuit offshore. Grand Island (left) still had only three homes, all built for Boston summer families by Cotuit housewrights. (Courtesy of Stan Solomon.)

**A Bridge over Little River.** Little River enters the bay here after a two-mile run from Santuit and Lovell's Ponds. Arthur P. DeCamp, who built this house in 1907, was a friend and sponsor of Mary Baker Eddy, for whom he established the first Christian Science international newspaper. He sold the house to the editor of the *Atlantic*, Mark deWolfe Howe, who entertained many famous writers here. (Courtesy of Alma Brackett.)

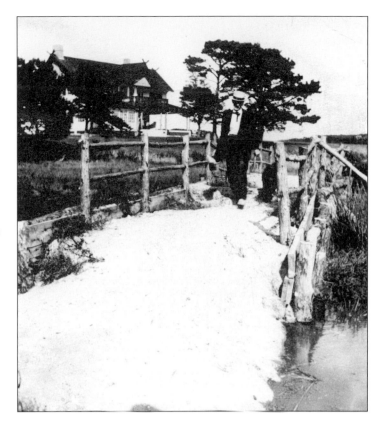

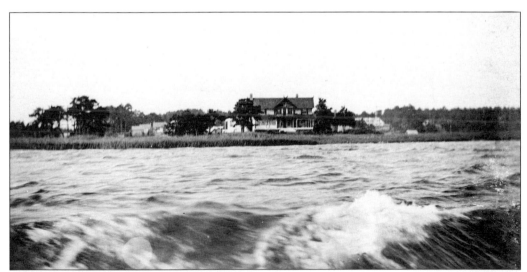

**A Swiss Chalet at Handy Point, c. 1907.** This unique summer home was built on Handy Point in 1907 by the St. Louis steel magnate Arthur P. DeCamp, perhaps with the inspiration of his famous brother, Impressionist painter Joseph DeCamp, a member of the noted "Boston Ten." To the left is the 1832 home of shipbuilder Josiah Handy, and to the right is the 1780 house of Heman Crocker. (Courtesy of Jean Crocker.)

**MARINE SCIENTIST OTIS BARTON, 1942.** Otis Barton held the world's record for a dive under the ocean, a half-mile, achieved with William Beebe in 1934 in Barton's bathysphere. He developed the prototypes in experimental dives here in Cotuit Bay. As a lieutenant in the navy, he is showing his nephew how to work a sextant to determine location by measuring the height of the sun. (Courtesy of Francis Barton.)

**HANNAH SCREECHAM, 1699.** Ralph Cahoon painted this fanciful picture of Captain Kidd, who buried a treasure somewhere along this coast with the aid of Hannah Screecham, who guards the hidden site at Noisy Point on Cotuit Bay with harrowing screams. So far, only a Spanish pillar dollar has been found. (Courtesy of the Cahoon Museum of American Art.)

*Eight*

# THE HEART
# OF THE VILLAGE

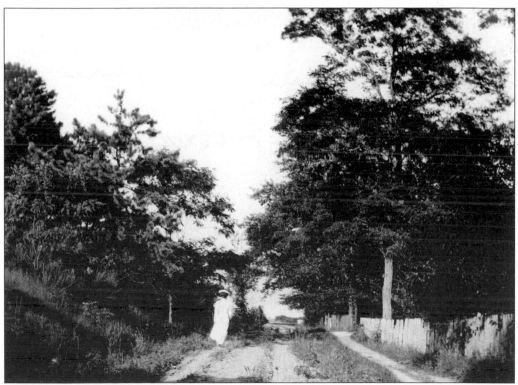

**A FAVORITE STROLL TO THE WATER, C. 1905.** This view looks down the lane now called Old
Shore Road from the post office on Main Street to the Upper Harbor, where one can see all the
boating activity and the changing tides and take refreshment at Nelson Nickerson's pier.

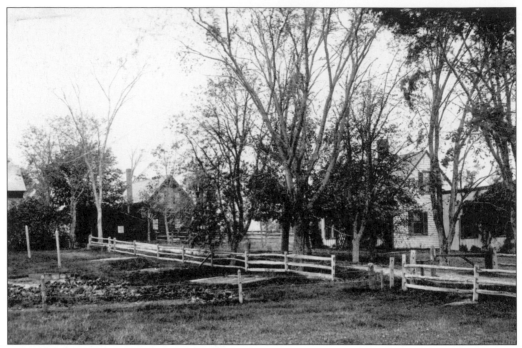

**HOOPER'S FARMHOUSE, BEFORE 1890.** The farmhouse at the right was built for Samuel Hooper *c.* 1856 by carpenters he brought down from his winter home on the North Shore. They built the unusual trapezoidal shape of the east end, called a Beverly kitchen, seen nowhere else on Cape Cod. To the left are Hooper's icehouse and the farm workshop.

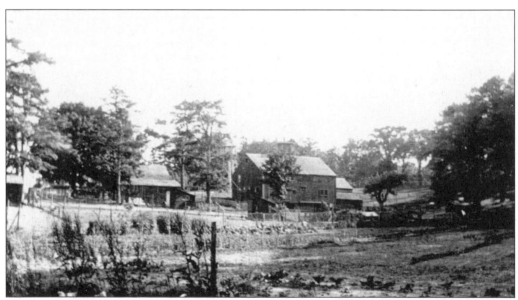

**THE LAST WORKING FARM.** On the wall of the pigsty to the left of the Ebenezer Crocker barn, built in 1794, was where Clover Hooper was sitting when the writer Henry Adams wooed her, successfully. Her husband memorialized her tragic death with the famous statue of grief by Augustus St. Gaudens. One of the last working farms of the town in 1964, it raised more than 2,000 chickens. (Courtesy of Sally Ropes Hinkle.)

**POSTMISTRESS AND SCHOOLTEACHER LIZZIE LOVELL, C. 1872.** Never married, Lizzie Lovell was born and raised in the so-called Red House, on Putnam Avenue. This photograph was taken about the time she was appointed teacher of the Santuit Grammar School, where she taught for two decades until she served as postmistress for 25 years, following her father, Capt. Andrew Lovell. (Courtesy of David Churbuck.)

**THE POST OFFICE AT THE CORNER OF OLD SHORE ROAD.** This was the social center of Cotuit for nearly half a century from 1890 to 1937. Everyone dressed up, men in coat, hat, and tie, and walked over here twice a day. Postmistress Lizzie Lovell read out the names. No street numbers were needed to address pieces of mail—just "Cotuit, Massachusetts." Lizzie's father, the Republican representative, built this office for her after his Republican president finally beat the Democrats.

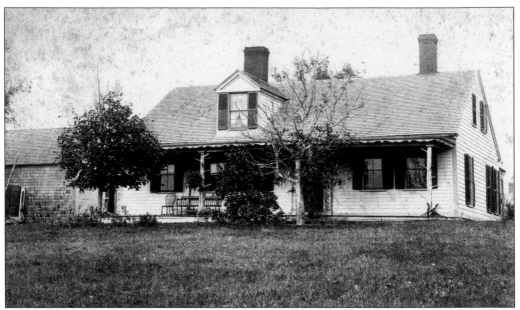

**A 19TH-CENTURY CAPTAIN'S HOME.** On the south side of Old Shore Road, facing east onto the water, Daniel Childs built this house before 1857, with saltworks in his front yard. Capt. Andrew Lovell ran the village post office here from 1882 to 1885 until ousted by the Democrats. (Courtesy of David Churbuck.)

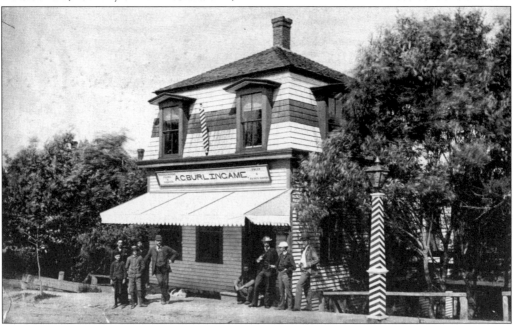

**ALVIN BURLINGAME'S STORE, 1880.** This store was built in 1876 at the corner of Main Street and Oyster Place. The boy in the hat to the left is "Blind" Chet Baker. In the doorway is future Harvard president Abbott Lawrence Lowell, whose summer home was directly behind the store. In the white hat is Frank Sturges, who took the shop over for a harness store in 1892. With them is "Charlie Fred" Fuller, whose barber poles over the door and on the street invite customers into his shop inside.

**PUBLIC SERVICE.** In the old New England tradition, where every freeman shared in the public jobs, Cotuit storekeeper Everett Hoxie (1869–1944) put in long hours as assistant town treasurer, sealer of weights and measures, slaughter inspector, and special policeman for 30 years, directing summer traffic through Hyannis. (Courtesy of Earlene MacDowell.)

**THE HOXIE GROCERY STORE, 1905.** Everett Lee Hoxie built this store on Main Street east of today's Cotuit School *c.* 1898 and sold groceries, candy, kerosene, cookies, tobacco plugs, molasses, and fresh eggs and milk from the Hoxie farm out back. He delivered in a horse-drawn wagon. On the steps is six-year-old Winifred Hazel Hoxie, who became master of the Santuit Grange and was noted for her brown bread served at Cotuit clambakes. (Courtesy of Earlene MacDowell.)

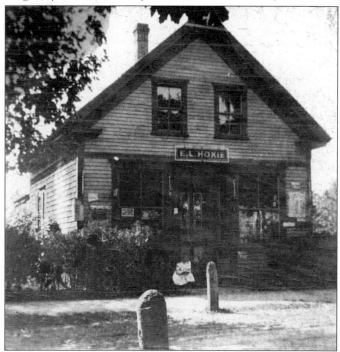

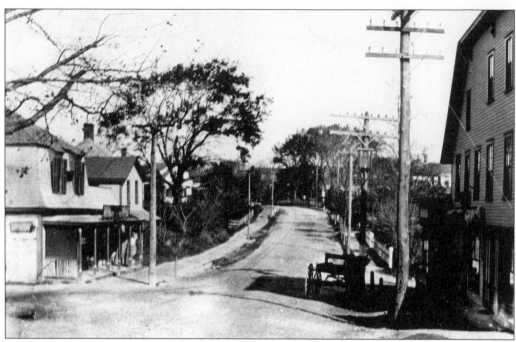

**DOWNTOWN COTUIT, 1910.** Looking north on Main Street, one can see both big stores, the Sears department store (left) before it was enlarged, and the old Sturges store next to it, soon to be the first firehouse. To the right is Fred Parker's grocery store, with a wagon out front. (Courtesy of Alma Brackett.)

**LOOKING WEST ON SCHOOL STREET, 1911.** In this view, on the left are Eugene Savery's shoe store and the Cotuit Oyster Company. Up the street on the right are the Sears store, on the corner; the Harlow butcher shop; a future sandwich shop, which had been a bike shop and plumbing store; a blacksmith; the Cotuit Band Hall; the steeple of the Methodist church; and the Lovell House, occupied by Capt. Francis Coleman's family. (Courtesy of Alma Brackett.)

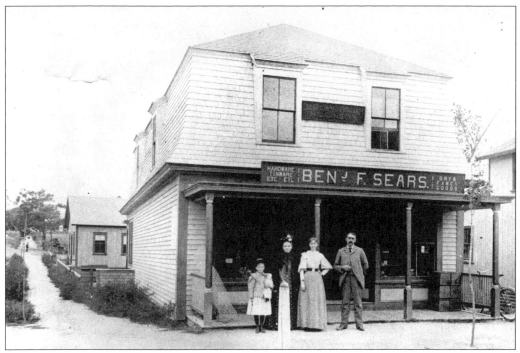

**THE SEARS DEPARTMENT STORE, 1900.** Benjamin Franklin Sears built a mansard-style department store (no relation to Sears Roebuck) on the site of the Ben Crosby store, which had burned down. To the left on School Street is the Harlow butcher shop, and on the right is the Sturges store, into which Sears expanded.

**A SEARS DELIVERY CART.** Every business in Cotuit made home deliveries. Benjamin F. Sears's department store, on the corner of Main and School Streets from 1890 to 1921, carried anything except perishables: hardware, clothing, shoes, carpets, medicine, tin pails, furniture, bolts of cloth, wallpaper, stationery, chinaware, and so on.

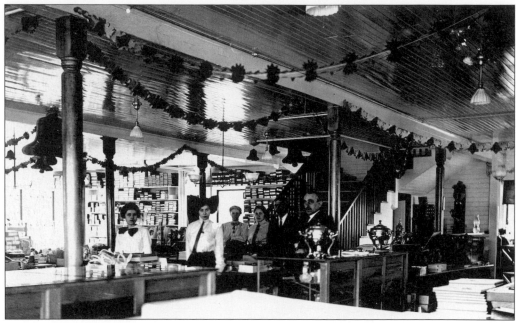

**CHRISTMAS AT THE DEPARTMENT STORE, DECEMBER 1908.** Red-and-green folding bells and paper garlands strung with Czech glass balls decorate the Sears department store for the holiday season. From left to right are Gladys Campbell, an unidentified person, Emma Crocker (who later took over the store), Wilhelmina Bates, village constable Seabury Childs, and owner Benjamin F. Sears.

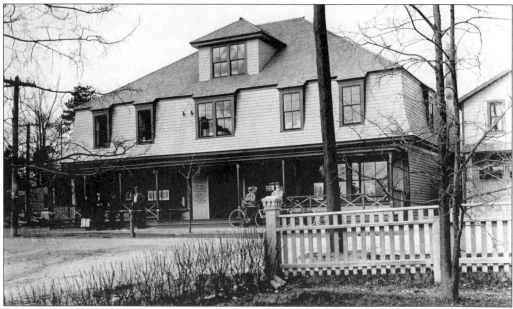

**THE SEARS DEPARTMENT STORE, 1913.** The grand mansard store is shown at its final stage. The tall white sign next to the door reads, "Second Floor: Clothing, Gents furnishings, Oil cloth, Carpets & Rugs, Wallpaper & Curtains, Fancy China / First Floor: Dry and Fancy Goods Store, Shoes & rubbers, Toilet goods & Medicines, Stationery & post cards / Basement: Hardware, Furniture, Farming tools & hardware, Horse blankets, Mops, and Stable goods."

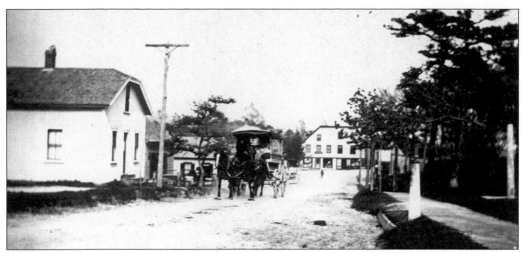

SCHOOL STREET, C. 1910. A traveling peddler's wagon with a team of two horses clops by the front of the Cotuit Band Hall, or Central Hall. At the end of the street, the three-story building is Fred Parker's grocery before it became the Coop. (Courtesy of David Churbuck.)

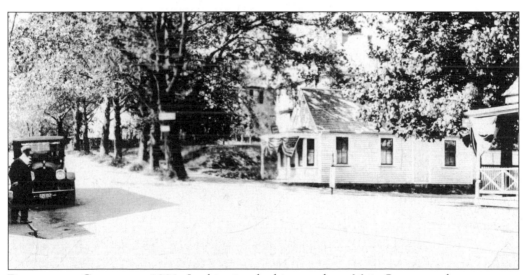

DOWNTOWN COTUIT, C. 1921. In this view looking south on Main Street are the two stores on either corner of School Street. To the left is Eugene Savery's shoe store that Capt. Seth Handy took over for a camera and variety store, run by his daughter Cynthia. To the right is a corner of the Sears department store. Note the yellow blinker in the middle of the intersection to direct traffic.

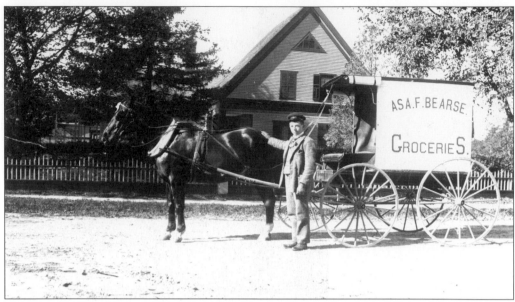

**ASA BEARSE'S DELIVERY CART.** Asa Bearse's store carried everything, as his sign read, "Groceries-Meats-Coffins-Robes-Flowers." Bearse retired from sailing coastal schooners to start the store in 1874. In 1882, he installed the first telephone in town. He also established a lending library, a hearse for funerals, and even a bowling alley. The deliveryman is young Henry Robbins, later a successful oysterman, stopped in front of the Charles C. Bearse house.

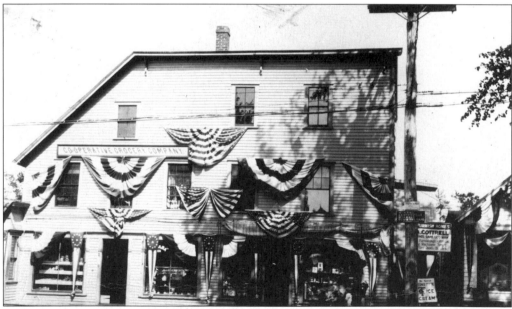

**THE ORIGINAL COTUIT COOP, 1918–1924.** When Fred Parker died of influenza in 1918, his brother-in-law Milton Crocker took over his grocery on a cooperative basis (hence, the name) with Sheriff Ulysses Hull, builder Howard Dottridge, and the owner of the department store across the street, Benjamin F. Sears. The Quimquisset Men's Club had a pool hall on the upper floor. The Cottrell furniture store was on the second, and on the right side was Frank Mercure, the French jeweler, whose absent-mindedness burned the place down in 1924.

**SCUDDER'S SERVICE STATION, 1938.** Walter Scudder is filling a customer's station wagon with gasoline while Roland Nickerson brings up full service, the water for the radiator in his left hand and a quart of oil in his right. Scudder tore down this building and the old Cotuit Oyster building behind it in 1950 and replaced them with the present gas station.

**CENTRAL HALL, SCHOOL STREET, 1903.** Just east of the Methodist church, this building was constructed for the Cotuit Brass Band. It was used for services by the Universalists and for the first services of the Christian Scientists (1897–1902), with Eliza Hodges as the first reader, succeeded by her sister, Santuit postmistress Ellen Chase. When the First Church of Christ, Scientist was built in 1902, this became a paint shop and, later, Edwin Landers's plumbing shop.

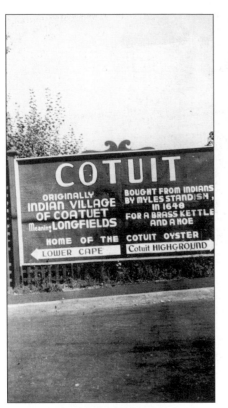

THE SIGN AT THE FOOT OF SCHOOL STREET, 1938. The tradition that Cotuit means "Longfields" was established in 1890 by Amos Otis, who cited old Colonial vocabularies and off-Cape histories. No one consulted the Native Americans themselves, and today we accept the translation "Place of the Council" given by Mashpee linguist Little Doe, who holds a doctorate from the Massachusetts Institute of Technology.

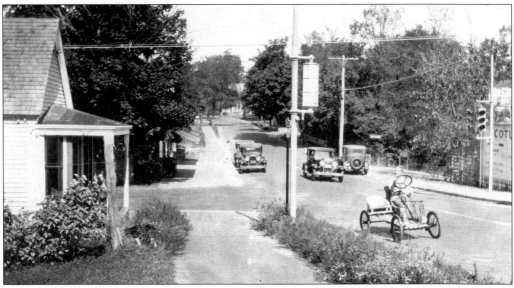

FOSTER NICKERSON AT THE TRAFFIC LIGHT, 1931. Heading south on Main Street, Foster Nickerson, who was born handicapped, zooms past the Handys' variety store in his specially designed delivery vehicle. The traffic light did not last long, for villagers found the halts frustrating, especially in winter, when there was no traffic, and soon ignored it. To the right, the sign directs traffic to the Cotuit hotels or to Hyannis and other parts of the Cape.

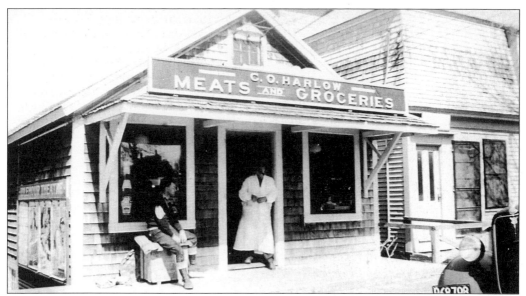

**THE VILLAGE BUTCHER, 1938.** Crosby's Fish Market was moved here in 1900. In 1918, butcher Charles O. Harlow opened the store that operated here for 34 years. Harlow, standing in the doorway, learned the trade from his father, Andrew Harlow, who had sold meat from a horse-drawn wagon, cut to order on your doorstep. Meat was slaughtered in an abattoir behind his house at 365 Main Street. The store is now an architect's office. (Courtesy of Earlene MacDowell.)

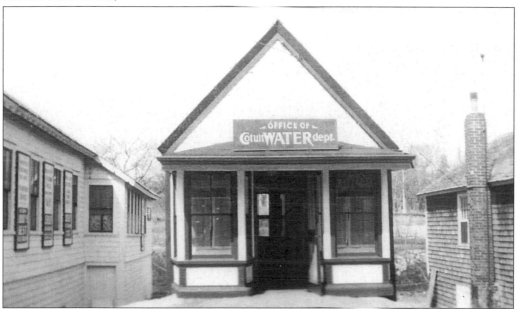

**THE COTUIT WATER COMPANY OFFICE, 1938.** This building is squeezed in between the today's Kettle Ho and Harlow's butcher shop. It was first built across the street as Eugene Savery's shoe store and was then used by Frank and Cynthia Handy for a variety and camera store. When Walter Scudder expanded the gas station in 1934, it was moved across the street for a bakery. Last, it was Holzman's tailor shop before moving to its present location at Old Oyster Road and Sampson's Mill Road at Main Street. (Courtesy of Earlene MacDowell.)

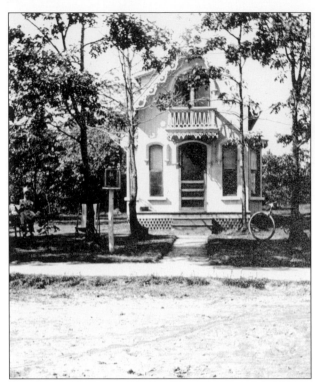

**A Summer Cottage on School Street.** Charles Gifford probably had Ozial Baker barge this lovely gingerbread cottage over from Oak Bluffs at the turn of the century and reerect it in the woods where School Street then ended at Piney Road. It was rented to many different people, including this happy couple rocking on the lawn. (Courtesy of Alma Brackett.)

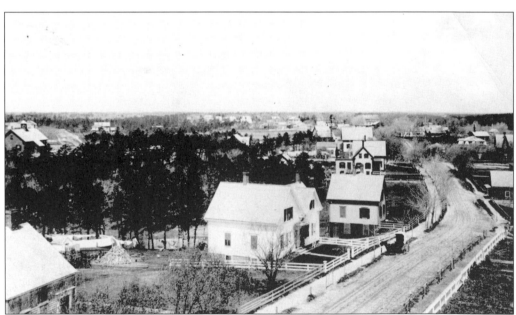

**Main Street from the Church Steeple.** A delivery cart stops at Capt. Joseph Hallett's, with Capt. Carleton Nickerson's house to the right. At the left is Capt. James Fish's house, below the Santuit School and Capt. Joseph Adams's on High Street. Farther up the street are whaling captain Seth Nickerson's big house and, beyond it, Asa Bearse's store—both of which are gone. On the right are Capt. Carleton Nickerson's store, the steep gables of Capt. Jarvis Nickerson's Gothic pile, and Irving Phinney's mansard-style building.

# *Nine*
# HIGHGROUND

COTUIT HIGHGROUND, THE 1880S. Two hurricanes drove the first settlers of Oregon (the original settlement at Rushy Marsh) to Highground, which developers tried to dress up as "Highlands." A cart road ran across open meadows to a sandy beach with a pier where the Nickersons docked and set out to large ships anchored off Dead Neck at Deep Hole.

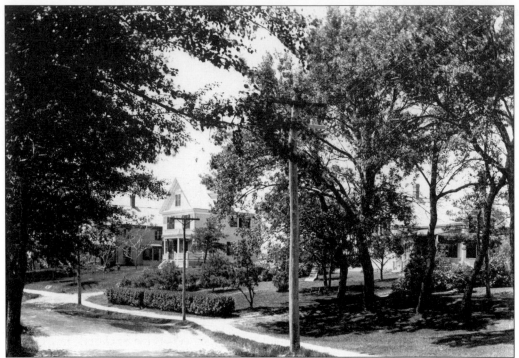

**LOWER MAIN STREET AT PINEY ROAD.** Note the bumpy sand road, hardened with clam and oyster shells, and the nice wide sidewalk. The house in the center was built by widow Ursalind Nickerson in 1885 after her old house burned down. Behind the trees is Capt. Hervey Fisher's house, which he moved in 1902 from the north side of Freedom Hall to this new location.

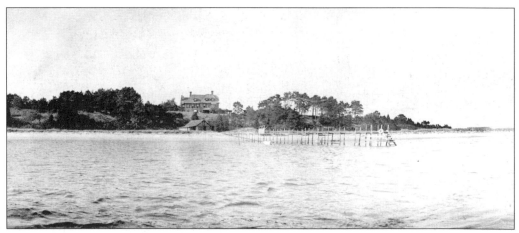

**BLUFF POINT, THE 1880s.** Col. Charles R. Codman's house had a grand view where only Samuel Dottridge's saltworks had stood earlier. Here he laid out the village's first golf course and had Frederick Law Olmsted landscape the garden. On the lawn, Codman continued the croquet he had introduced to America at the Lovell House.

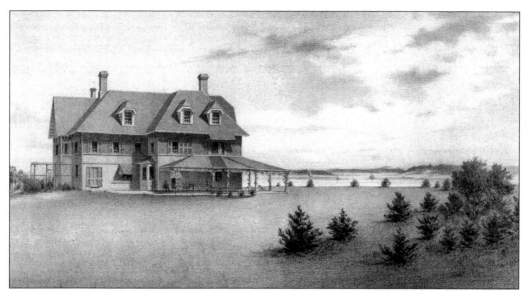

**COL. CHARLES CODMAN'S MANSION, 1880.** Charles R. Codman, who commanded the 45th Massachusetts Regiment, returned from the Civil War to have Santuit builder Charles Baxter follow the plans of Boston architect John R. Sturgis to copy his favorite summer home (the Lovells' Red House on Putnam Avenue) to build in 1867 this Victorian Stick-style mansion on Bluff Point.

**THE HANDY BROTHERS SHOE AND PHOTOGRAPHIC STORE.** Retiring from the sea, Capt. Seth Handy set up store in his mansard home on the corner of Handy Street (now Sea Street) and Ocean View. He advertised, "Dealer in Shoes, also Kodaks, Photo Supplies souvenir postcards, confectionery, soda, etc. A specialty is made of developing and printing for amateurs." After this building was torn down in 1906, Handy opened a new store in the center of the village.

**THE SAMUEL DOTTRIDGE HOMESTEAD, BEFORE 1961.** The homestead was built in Brewster in 1808 by Samuel Dottridge. It was brought by oxen over rough sandy roads to Ocean View Avenue, the family living in it en route. Used as the laundry of the Pines Hotel, it was restored to its original full Cape style (by removing the cross gable) and was placed nearby in its present location on Main Street.

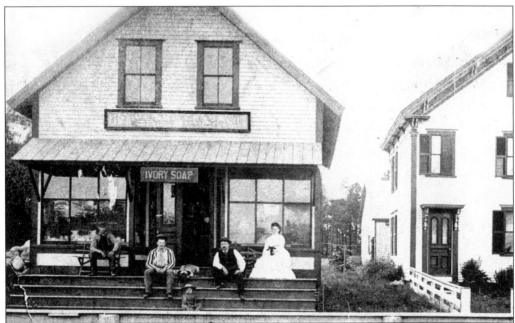

**THE SUNSET CLUB AT ALEX NICKERSON'S STORE, 1896.** James Herbert Morse noted in his journal that the Sunset Club "showed a comfortable warmth flavored with the scent of coffee, sugar and other good things. . . . Affairs . . . were going on slumberously. . . . Even the flies do not wake up, although there was the odorous appeal of molasses and of salt fish, brooms and fuzzy ropes for them to settle on. [Outside] 'the Sunset Club' . . . were all at the door, taking their after-dinner smoke and gossip."

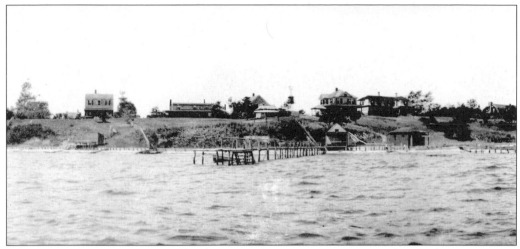

THE ENTRANCE TO COTUIT HARBOR, C. 1898. Old sea captains' houses lined the bluff along today's Ocean View Avenue, replaced by grand summer mansions, the first of which is Rothwell's Rosemead (second from the right), with its sugarloaf carriage house. To its right is the Pines Hotel (with the tower). From left to right (above Loop Beach) are the homes of Urial Hutchins, James H. Handy, and George H. Fuller; Aaron Nickerson's store; and the homes of captains Ensign Nickerson and Oliver Lumbert.

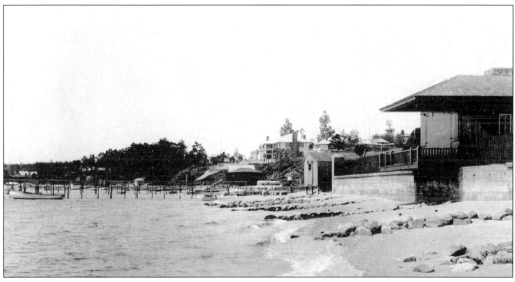

ROTHWELL'S BREAKWATER AT THE ENTRANCE TO THE BAY, C. 1910. James E. Rothwell, the "Cement King," is supposed to have had this breakwater at the harbor entrance poured overnight and the beach house built above. Oyster barrels lie next to the shanty where Riley's Beach is today. Beyond, the Horace Sears mansion (designed by Guy Lowell) is under construction by Howard Dottridge. (Courtesy of Jean Crocker.)

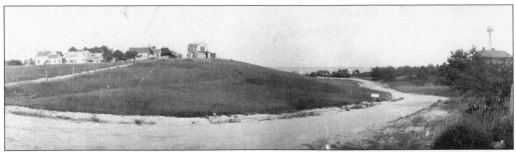

THE LOOP, C. 1910. When this photograph was taken, the road down from Main Street had just been cut but marked with a sign reading, "PRIVATE / WAY / DANGEROUS." The Morse house is on the right, and the Nickerson houses are on the left. The beach had just been acquired by the town. Two sails are visible, one probably at Dr. Walter Woodman's pier, where the Mosquito Yacht Club docked, and another off Morse's.

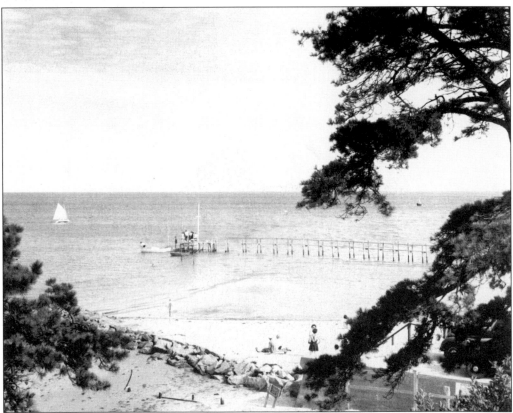

LOOP BEACH, 1944. This is Cotuit's favorite beach, a lovely sandy strand on Nantucket Sound at the entrance to the harbor. In the 19th century, the sailors used to put out from the pier to board the schooners anchored at Deep Hole. In 1906, the town officially took the beach from Willis Nickerson and James H. Morse. (Courtesy of David Churbuck.)

**LIBRARY FOUNDER AND THE OLD SCHOOLMASTER, 1918.** Lucy Gibbons Morse, the daughter of a Quaker woman reformer, was a founder of the Cotuit Library and was a gifted artist. Her husband, James Herbert Morse, who ran a New York preparatory school, was a poet and diarist who recorded Cotuit events from 1872 to 1923. This photograph shows them at Bonny Haven, the old Seth Nickerson house. (Courtesy of the Morse family.)

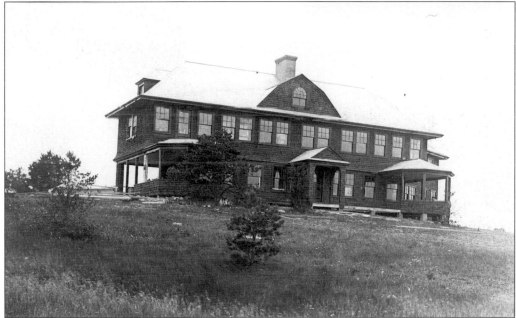

**BUILDING HOUSES.** Howard Dottridge and his crew finish the so-called Morse Big House above the Loop in 1908. Dottridge was the third generation of Dottridge housewrights in Highground, starting with his grandfather Samuel Dottridge, who built the homestead in 1808, and his father, John, who built Freedom Hall in 1861. Harvard's purchasing agent, William Morse, had him build this Shingle-style home on plans of Boston architect William Ralph Emerson.

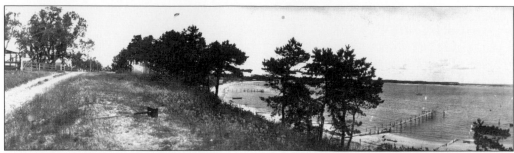

**Loop Beach, Ocean View Avenue.** The Nickersons had built a pier on their beach here, which lasted until the 1880s. In 1906, the town took land from them and the Morses to create a public landing. The pier is probably Dr. Walter Woodman's, where the Cotuit Mosquito Yacht Club was born in 1906. Ocean View is a two-track sandy road, overlooked by Horace Nickerson's porch.

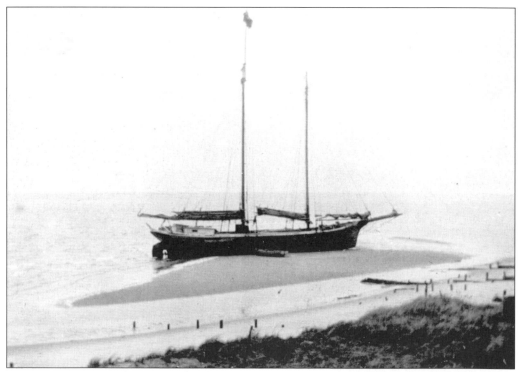

**The Schooner Mary E. Snydam aground at Loop, May 1914.** So many ships were wrecked off Cotuit that Abbott Lawrence Lowell was able to salvage the cabin of one to build his study, which he called the Caboose. The kids' favorite wreck was a steamer load of watermelons that washed ashore for taking. Others, such as this one, were saved by removing the cargo and floating it off at high tide.

# Ten

# A FAVORITE
# SUMMER RESORT

THE FIRST HOTEL ON CAPE COD. Hezekiah and Dorothy Coleman opened a small boardinghouse for passengers waiting for a ship to Nantucket (or for those arriving late), charging 25¢ a night and 10¢ for breakfast in 1830. Business grew fast after the railroad came in 1854, so the Colemans opened the Santuit House in 1860. It originally had 80 rooms and, in 1873, was expanded to 200 rooms. This famous landmark burned down in 1925.

**COTUIT'S FIRST SUMMER RESIDENT, 1849.**
Samuel Hooper was a wealthy China merchant who came to Cotuit to find a captain to take a ship to San Francisco. The postmaster in the Ebenezer Crocker house agreed to sail if Hooper would purchase the farm. Hooper became Cotuit's first summer resident, and the property stayed in the family for nearly a half-century, used by Hooper, a powerful U.S. representative, to entertain cabinet members. (Courtesy of Conrad Geyser.)

**THE EBENEZER CROCKER HOUSE.** The oldest house in Cotuit Port, this home was built for state representative Ebenezer Crocker in 1793. U.S. Congressman Samuel Hooper added the porch on rustic cedar posts after 1850. This picture was taken before the 1890s, when one of Hooper's partners in the China trade, Gen. John Reed, added the "nose" above the front door.

**WILLIE IRWIN, STAGE SERVICE.** James Morse described Willie Irwin this way: "Stout and red-faced, he looked in every respect like a portly Hollander stepping out of one of Rubens' broad canvases." He delivered freight, including outgoing oysters and incoming beef and lamb for the butcher, and picked up the telegraph messages at the station.

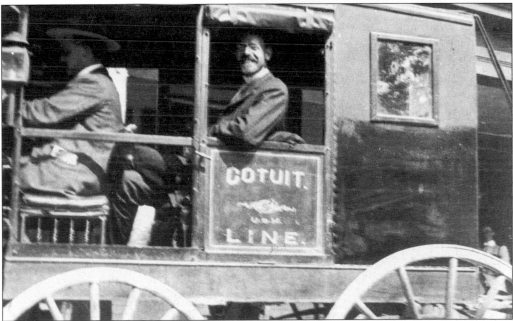

**THE STAGECOACH FROM WEST BARNSTABLE STATION TO COTUIT.** Willie Irwin was a popular stagecoach driver for many years. From 1893 to 1919, he waited at the West Barnstable station for the arrival of the train from Boston and Fall River, loaded the mailbags and packages from the baggage car, and drove passengers on the eight-mile ride to Cotuit, over sandy roads right to your front door.

**THE SANTUIT HOUSE AT ITS PEAK, C. 1900.** Seen from Main Street, Cape Cod's first hotel is expanded from the little 1805 cottage of Hezekiah Coleman, who had opened the boardinghouse by 1830. His son Braddock opened the hotel in 1860, doubled it, and added a ballroom. By 1895, his daughter Elizabeth and her husband, James West, had added a story to the former Alpheus Adams cottage (center) and built a mansard-roofed annex (right).

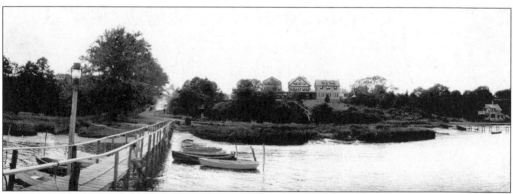

**THE SANTUIT HOUSE FROM THE WATER.** The hotel complex at the top of the picture includes, from left to right, the mansard-roofed annex, the much expanded Alpheus Adams house, the main 1878 addition, and the original 1805 boardinghouse (which was expanded into the Cape's first hotel in 1860). Down on the waterfront by the Mudhole is the Porter House, once a blacksmith's shop.

108

**A PROFESSIONAL PHOTOGRAPHER'S CART, 1878.** Provincetown photographer G.H. Nickerson's cart is parked on the lawn of Santuit House, next to the proprietor, Martha Bearse Coleman (in the shawl), with her granddaughter Mary West, whose father, James West, took over and expanded the hotel. Below is the Coleman wharf, with two schooners inshore and one offshore, probably those of the richest man in town, Nathan Coleman.

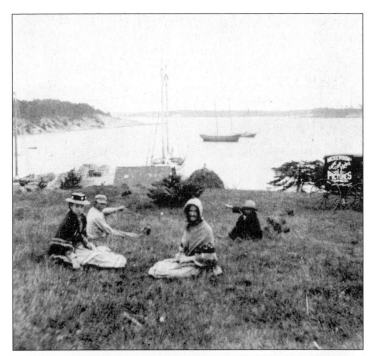

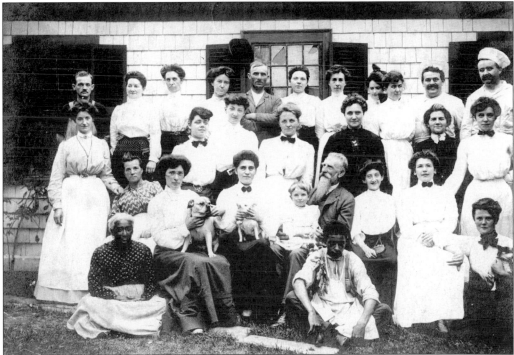

**THE SANTUIT HOUSE STAFF WITH JAMES WEBB, PROPRIETOR.** After three generations as hoteliers, the Colemans lost the hotel after the Civil War. The Santuit House reached its peak after cranberry grower James Webb bought it in 1880, expanding to the new annex and Hillside House, with stables on the west side of Main Street. After James Webb died in 1918, management was taken over by his daughter Abbie Bodfish.

**THE BALLROOM OF THE SANTUIT HOTEL, 1906.** In the 1870s, James and Clara Coleman built this spacious ballroom and music hall on the north side of the big hotel. A big fireplace provided heat for chilly evenings, and kerosene lamps lighted the hall at night.

**CROQUET AT THE SANTUIT HOTEL, 1906.** Croquet was first played in America before the Civil War at the nearby Lovell House, introduced by Col. Charles Codman from England. Every house had a windmill to pump water from shallow wells into the attic tanks for the new bathrooms that the plumbers installed in every home. There were so many clattering windmills, one for each house in the village, that the poet James Morse likened Cotuit to Holland.

110

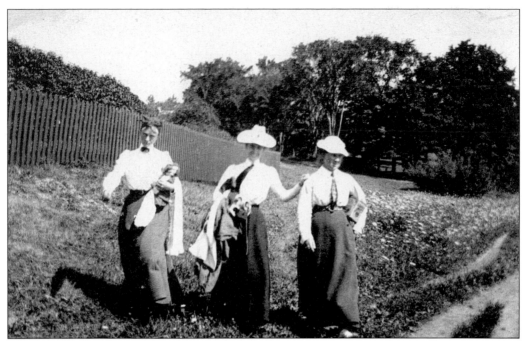

**OFF FOR A BOAT EXCURSION, 1899.** Three ladies pose among the daisies in summer sporting attire, including neckties, as they come down Old Shore Road to the Nelson Nickerson dock for a sail around the bay or out to Nantucket Sound.

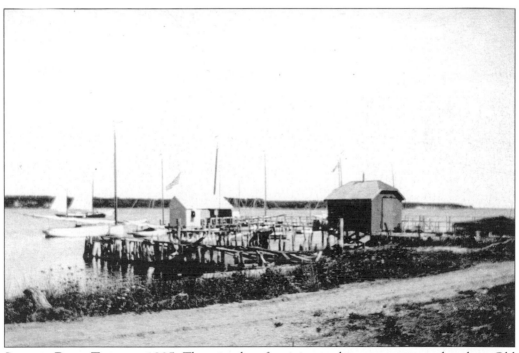

**SUMMER BOAT TRIPS, C. 1905.** There is a lot of activity on this sunny summer day along Old Shore Road. A party is waiting on the Santuit House dock, and a boat is ready to sail from Nelson Nickerson's dock, where one could buy refreshments, as advertised on the roof.

**WAITING FOR A SAILING EXCURSION, 1899.** Lined up on Nelson Nickerson's dock are a couple of families waiting for Capt. Phinney to take them out in his catboat for a sail around Grand Island or out into Nantucket Sound. At the dock, one could buy ice cream, tonic, and freshly opened oysters and quahogs on the half shell.

**CAPT. HARRISON GRAY PHINNEY AT THE HELM OF THE CARRIE ALLEN.** After retiring as master of coastal schooners, Harrison Gray Phinney took summer folk out for sails on his catboat. Most of his living came from carpentry on new homes in the village. Phinney married three times, first to a Kentucky belle named Edmondia, then to a California lady Amelia, and finally to his niece, Ellen Phinney, a marriage that is prohibited under state law.

**THE FOOTPATH ALONG LOWELLS' BLUFF,
c. 1910.** The well-trodden character of this
path indicates that it may have been a
favorite walk from Hooper's Landing to Little
River, where there was a bridge to Handy
Point. The silhouettes of the pitch pines
were lovingly recorded by Impressionist
painter Frederick Lowell, who grew up here.
(Courtesy of David Churbuck.)

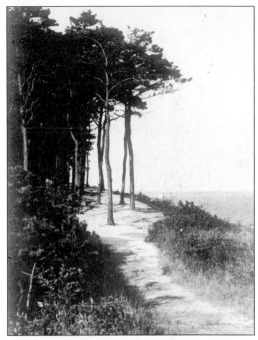

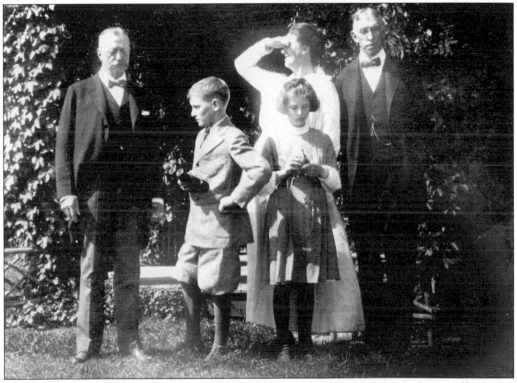

**THE SUMMER HARVARD.** Abbott Lawrence Lowell is on the front steps of the house of his wife's
first cousin, Alice Lowell (looking out to sea), with her husband, James Hardy Ropes (Hollis
Professor of Divinity at Harvard) and their two children, Eddie (born in 1909) and Harriet (born
in 1908), longtime historian of Boston and Cotuit. (Courtesy of Sally Ropes Hinkle.)

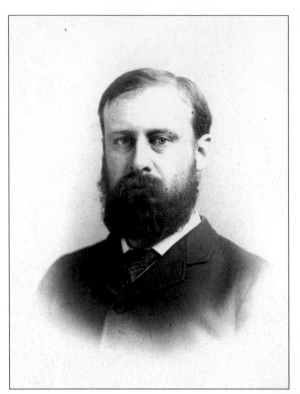

HISTORIAN EDWARD JACKSON LOWELL. Edward Jackson Lowell, an eminent historian who wrote a history of the Hessians and *The Eve of the French Revolution*, first came to Cotuit in 1874 and lived in the Lovell House. His first wife had just died, although she had been tended by no less a doctor than Oliver Wendell Holmes. He remarried Elizabeth Jones and moved to the Ebenezer Crocker House, the oldest in Cotuit Port. He died there unexpectedly at age 49. (Courtesy of Roger Barzun.)

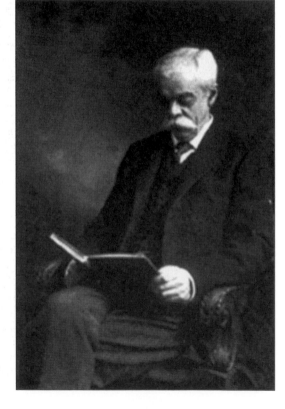

JUDGE FRANCIS CABOT LOWELL. Francis Cabot Lowell was the only son of George Gardiner Lowell, who built "the Place" on the point above Oyster Place landing, where Francis grew up, sailing and swimming. He became the judge of the First U.S. Circuit Court of Appeals and wrote several books, including a novel and a book on the life of Joan of Arc. He continued to visit the house after his sister and her husband, the president of Harvard, took over the Place. (Courtesy of Charles Lowell.)

**COTUIT BAY FROM LOWELL'S BLUFF.** Frederick Lowell grew up in Cotuit and inherited the choice middle piece of the property with his favorite view of the harbor, with Dead Neck and Codman Point in the distance, through the pitch pines, which grew down to the water's edge. (Courtesy of Charles Lowell.)

**IMPRESSIONIST ARTIST FREDERICK ELDRIDGE LOWELL, C. 1900.** Relaxing in his gunning shack on Sandy Neck, this Cotuit artist is surrounded by his sketches of the dunes and Cape Cod Bay. Lowell's paintings of Cotuit include pines silhouetted above Cotuit Bay. He inherited the middle portion of his father's estate, where the Lowell descendants still live. (Courtesy of Roger Barzun.)

**HAYING ON THE COOLIDGE FARM.** A boy gets the joy of riding one of the horses that pulled the hay rake at the back of the Dr. Algernon Coolidge estate between Main and High Streets. On the advice of the great naturalist Alexander Agassiz, the doctor planted many exotic trees, including an "upside down tree." (Courtesy of Conrad Geyser.)

**THE COOLIDGES' OCTAGONAL WINDMILL.** Every family had a windmill to pump the water from the wells to the attics of the houses. Abbott Lawrence Lowell's can be seen in the distance. The brahmin Coolidges outdid everyone with this stylish octagon, on the meadow between the Main Street house and Hooper's Landing. (Courtesy of David Churbuck.)

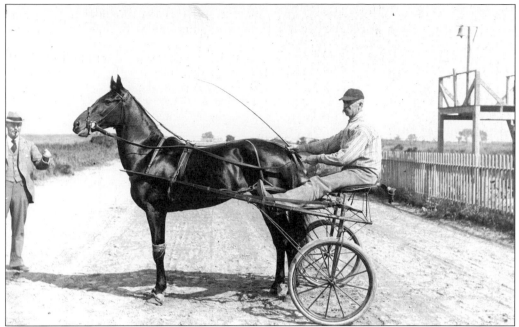

**CAPT. ULYSSES HULL'S DANDY EASTMONT, 1894.** Capt. Ulysses Hull, one-time county sheriff, loved fast racing horses, which he exercised at Cotuit's own track, at today's Ralyn Drive. His sulky driver Henry Swain is shown at the Barnstable Fairgrounds.

**FROM FAST HORSES TO FAST CARS.** Capt. Ulysses Hull, who loved fast ships and fast horses, took naturally to the fast car. In 1906, the Stanley brothers introduced their steamer, which set a record for a steam-driven automobile (over 120 miles per hour, a record that has never been beaten). The only problem was that because water freezes in winter, the car took too long to heat up and you might as well get out the old mare.

**THE FISH CHILDREN IN GOODSPEED'S DONKEY CART, 1888.** Elizabeth (left), Charles, and Lavarah, the children of Charles E. Fish and Mary E. Rowe, are shown in front of their house opposite the Cotuit schoolhouse (now the library). The donkey probably belonged to the Crocker farmer Howard Goodspeed, whose cousin Charles grew up in Cotuit and founded Boston's famous bookstore.

**MILTON GIFFORD, COTUIT'S PITCHER, 1909.** Milton Francis Gifford, the 17-year-old pitcher of the Elizabeth Lowell High School team, sits in front of his family home on School Street. By the 1930s, Cotuit boys were playing the Cape Twilight League and, after World War II, formed the Kettleers. The team has won 13 Cape championships and provides players for the major leagues. (Courtesy of Alma Brackett.)

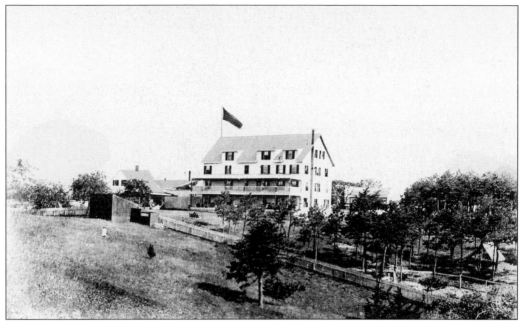

**THE PINES HOTEL FROM THE BEACH, 1893.** This was the first incarnation of the Pines, when it expanded from a simple captain's cottage (left), where the Morses ran a boardinghouse. Shortly after this, they added a three-story gambrel front on the north, capped with a tall tower.

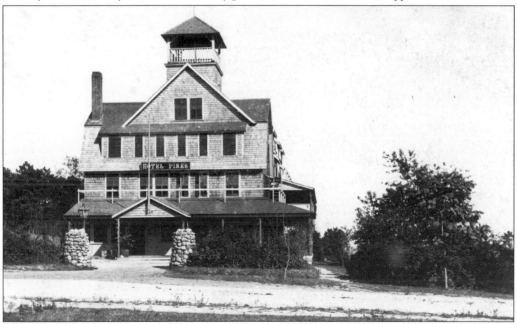

**THE PINES HOTEL.** A promotional leaflet for the hotel advertised, "This is the original inn, rich in happy events and historic tradition, situated in the tree-lined village." The hotel was started in 1893 by John and Elizabeth Morse as a boardinghouse in an old sea captain's cottage. It grew into this big building in 1900, with 33 rooms. It was featured as "a family resort," and no liquor, pets, and gambling were allowed. The "American meal plan" included three home-cooked meals.

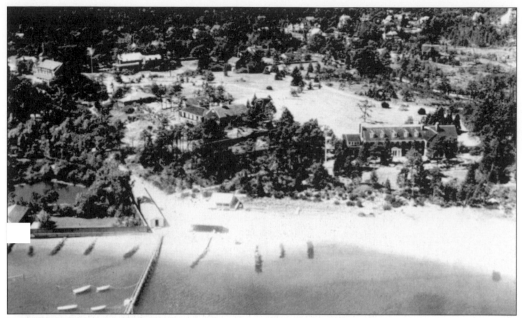

**EVERGREEN.** After World War II, the Pines added the biggest house in Cotuit, with 17 bedrooms, each larger than the hotel rooms, and 9 baths. It was built in 1924 as a summer cottage by a wealthy Chicago family, the Rolosons, and surrounded by fine evergreen trees. Adele Roloson could not bear the memory of a son who died in a fire in their Winnetka home, so she sold this to build another cottage across the bay on Oyster Harbors.

**THE PINE TREE TEA ROOM.** This was the favorite afternoon meeting place for ice cream and sodas. It also featured a little gift shop to buy souvenirs to take home to the folks. A well-known insurance executive converted his family's cottage next to the hotel into a fine summer home, Hyworth (filled with Colonial antiques), and offered it to the hotel, which remodeled it again.

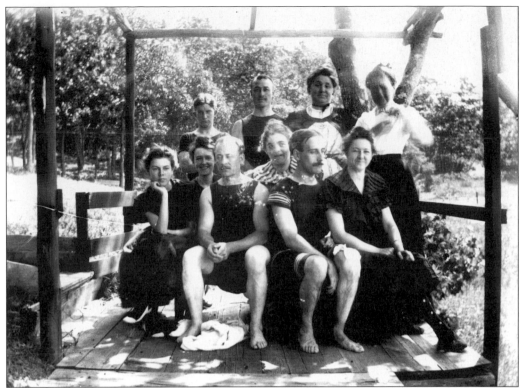

A SWIMMING PARTY AT THE PINES. The hotel beach was great for surfless swimming in the 70-degree saltwater, safe for the kids at all times. For many years, John Ward, schoolmaster at the Watertown Junior High School, was the popular instructor in charge of swimming and sailing lessons. This photograph was taken before World War I, when men wore tops to swimsuits.

THE PINES BATHHOUSES AND BEACH, 1915. A long line of bathhouses provided a bucket to wash the sand off your feet before going into the bathhouse. This narrow boardwalk was the only access to the Pines Beach. The sign reads, "Auxiliary Power Boat / STORM KING / Ready for Any Business / Daily at Pines Wharf, / S.N. Handy." (Courtesy of Henry Walcott.)

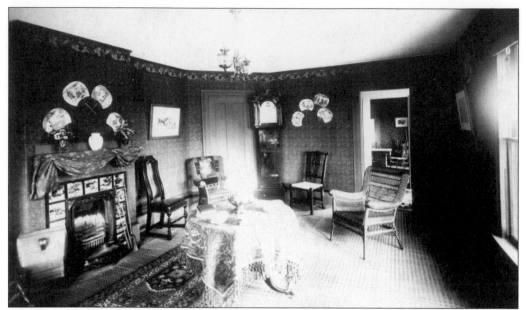

**A VICTORIAN SUMMER PARLOR, 1880.** The parlor of the summer home of well-to-do insurance executive Alexander Adams sets the style with Japanese fans, wicker chairs mixed with Chippendale, a coal fire grate surrounded with picture tiles, a rattan floor covering with Persian rug, gaslight and kerosene lamp, a paisley-fringed tablecloth, and a grandfather clock.

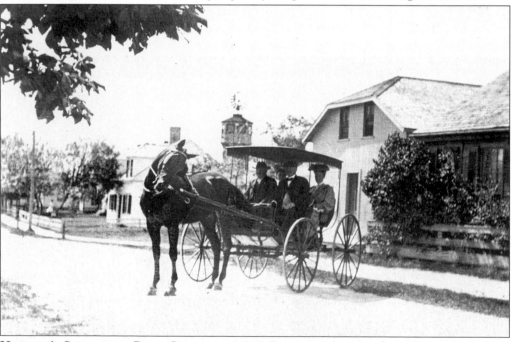

**HARLOW'S SURREY FOR PINES GUESTS, C. 1905.** Daytime excursions through the woods along shady roads were welcome diversions; one of the favorites was to Wakeby Pond. Here, Roland Harlow takes a party from the front of the hotel. In the right background is the Casino pavilion for parties and entertainment, such as bingo. Behind the Casino were tennis courts. On the far right is the laundry of the hotel in the Dottridge homestead.

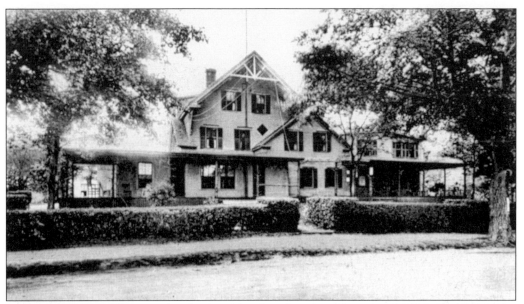

**THE COTUIT INN.** This was the third and last hotel in the village, until 1986. Opened in the mid-1890s, it was called the Central, perhaps because it was halfway between the two larger hotels and in the center of the village. Developer and former Cotuit High School teacher Charles L. Gifford had his real estate and insurance office in the north side of the building. It was managed by his wife, Fannie, who had run their Sagamore hotel.

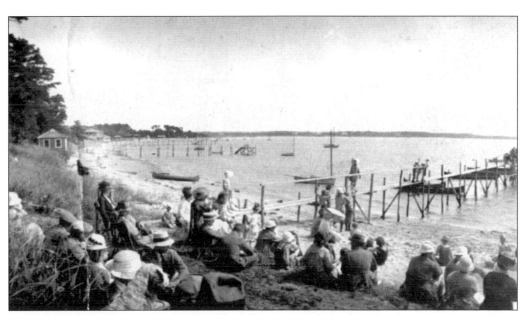

**A SUMMER SWIM EVENT, C. 1913.** All of the parents showed up for this event at the Sears Beach, with yacht club members watching from Dr. Walter Woodman's pier to the right. Too many local kids drowned, and the Cotuit Mosquito Yacht Club made the ability to swim a requirement for membership.

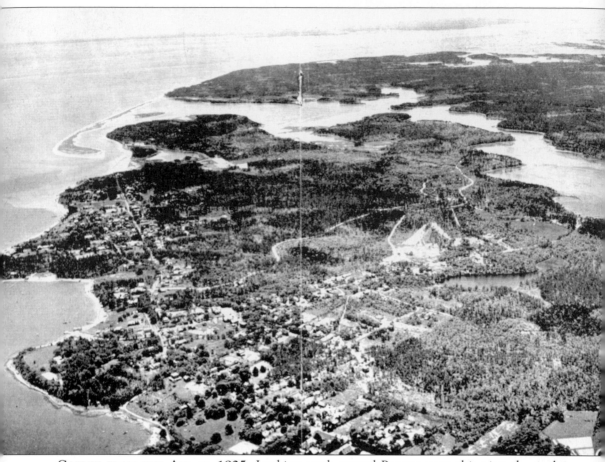

**COTUIT FROM THE AIR, C. 1925.** Looking south toward Popponesset, this view shows the landmarks of Cotuit. Noticeably missing is the Santuit House (which burned in 1923), although its annexes still stand. Prof. Guillermo Hall's Spanish Castle has been built at the head of Shoestring Bay, as has Robert Fowler's house on newly opened Popponesset Road.

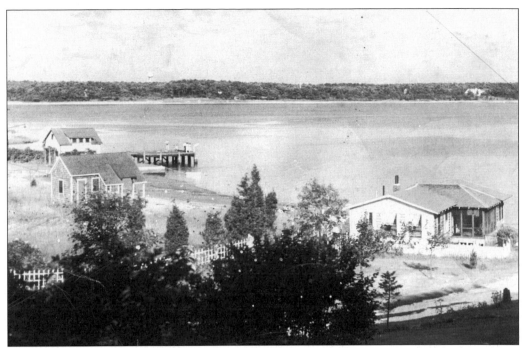

**FALL IN COTUIT.** This photograph, taken before the 1944 hurricane, shows a tranquil scene of the town dock, Congressman Charles L. Gifford's district office (with the three windows), the Whites' beach cottage, and the Crawfords' summer house. (Courtesy of the Cotuit Library.)

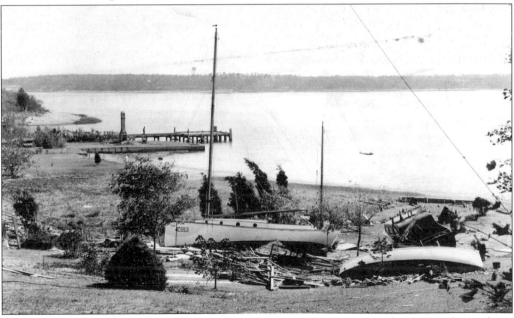

**AFTER THE 1944 HURRICANE.** This photograph shows the same area after 100-mile-per-hour winds tore across Cotuit. All that remains of the congressman's office is the chimney. The beach cottages are washed into heaps of debris, topped with beached boats such as *Spindrift*. German prisoners of war came from Camp Edwards to clear trees from the blocked roads. (Courtesy of the Cotuit Library.)

**THE SITE OF THE WARDEN'S PIT.** Here, in 1849, bank robber William Phillips persuaded his jailer and the Charlestown Prison warden that he had hidden $50,000. As reported in Boston newspapers, they came to this spot and dug until the robber pushed his gullible warders into the pit and escaped. (Courtesy of Stan Solomon.)

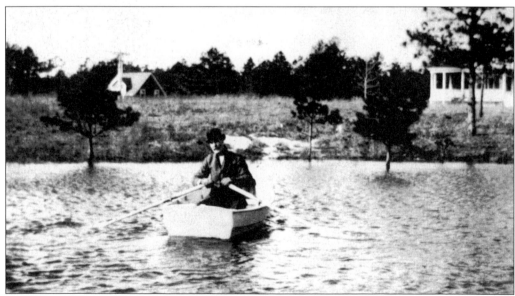

**WINTER IN COTUIT, FEBRUARY 11, 1911.** Nor'east gales can flood low-lying areas such as Rushy Marsh and Old Shore Road. In this view, the Loop is flooded almost to Main Street.